A GIACOMETTI PORTRAIT

FARRAR, STRAUS AND GIROUX

NEW YORK

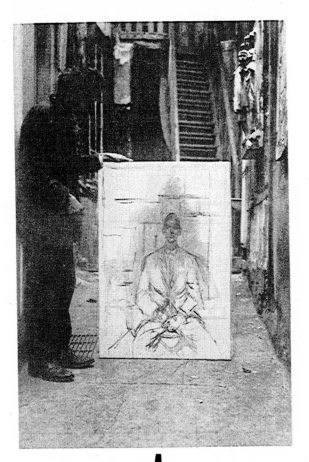

A
GIACOMETTI
PORTRAIT

Farrar, Straus and Giroux
19 Union Square West, New York 10003

Distributed in Canada by Douglas & McIntyre Ltd.
Printed in the United States of America
Originally published in 1965 by The Museum of Modern Art
First revised edition published by Farrar, Straus and Giroux in 1980

Library of Congress Cataloging-in-Publication Data
Lord, James.
A Giacometti portrait / James Lord.— Rev. ed.
p. cm.
Hardcover ISBN-13: 978-0-374-16199-6
Hardcover ISBN-10: 0-374-16199-2
Paperback ISBN-13: 978-0-374-51573-7 (pbk.)
Paperback ISBN-10: 0-374-51573-5 (pbk.)
1. Giacometti, Alberto, 1901–1966. Portrait of James Lord.
2. Lord, James. 3. Artists' models—Psychology. I. Title.

ND553.G56 A7335 1980
759.9494

80012641

Designed by Cynthia Krupat

www.fsgbooks.com

24 26 28 29 27 25 23

For Alberto

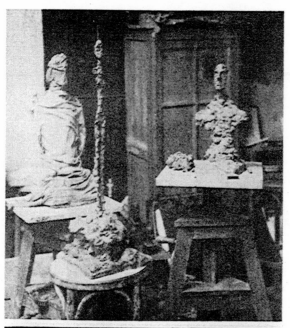
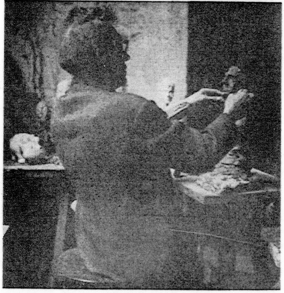

(*above*) The passageway with the entrance to Giacometti's studio at the left
(*opposite, top*) Sculptures Giacometti was working on during the time of the portrait
(*bottom*) Giacometti working on the bust of Diego from memory

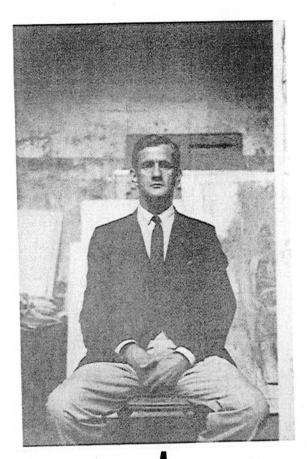

A GIACOMETTI PORTRAIT

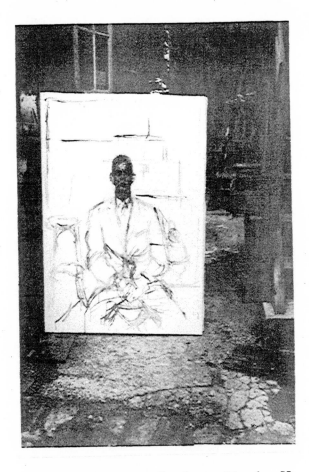

Giacometti had gone to London on Tuesday. He was anxious to see the rooms at the Tate Gallery in which his retrospective exhibition is to be held in the summer. Although he likes London and has friends there, he always feels that he cannot spare much time from his work and consequently planned to be away only a few days, returning to Paris on Friday. We had agreed that as soon as he got back I would pose for him. His idea was to do merely a quick portrait sketch on canvas. It would

take but an hour or two, an afternoon at most.

Saturday was the twelfth of September. I went to the studio about three o'clock. It would have been no surprise to discover that he hadn't returned. His plans are always subject to unexpected change. But I found him sitting in the room where the telephone is, staring at the floor. When I asked him how it had been in London, he said, "All right." Then he looked at me curiously for a minute and said, "Shall we work for a little while?"

We went down the open passageway to his studio. He began at once to work with the clay of a slender female figure about two feet tall which had been his constant preoccupation for the past weeks. Occasionally he would murmur, "Merde!" and from time to time he reached out and tweaked the clay of a smaller figure on the stand beside him.

"We'll work for a little while," he said, "just for a little while, because later I want to work on the bust of Diego."

Diego Giacometti is Alberto's brother, assistant, model, and closest friend. His studio is only about twenty-five feet back along the passageway from Alberto's, beyond the bedroom and the telephone room. There he not only makes plaster casts of his brother's sculptures and patinates the bronzes but also designs and builds in bronze some of the handsomest contemporary furniture. The bust to which Alberto referred, one of the scores he has done of his brother, was about eighteen inches high, modeled directly from life and very little distorted. It stood on the cluttered, dusty table just below the large studio window.

I sat down on a wicker chair and waited. Alberto appeared to be in one of his more somber moods. Several times he exclaimed that nothing | 4

he did was any good, that he didn't know how to do anything, and that there was no hope of changing that. Ten, fifteen, twenty minutes passed. From time to time he glanced at me. On one of the sculpture stands there was a large bust wrapped in plastic. Presently he began to remove this plastic, uncovering the rags underneath which he carefully unwound one after another and threw on the floor. It was like seeing a mummy being unwound after thousands of years. He was surprised and pleased to find that the rags were still damp, for it had been three months since he had worked on the bust, a portrait from life of a friend.* He then began to gouge and press and squeeze the clay so violently that several lumps of it dropped off onto the floor. After some fifteen minutes he went out into the passageway, came back with a bucket of water, wet the rags, and carefully wrapped them again around the bust. Then he started to work on the tall figure once more. Some time passed. Suddenly he turned, went into the corner of the studio and started to rearrange the bronze figures standing there, which banged and clanged as they knocked against each other. Nearly an hour had passed. He seemed to be avoiding desperately the moment when he would have to start work on something new. He is so poignantly aware of the difficulty of making visible to others his own vision of reality that he must be unnerved by the necessity of having to try to do it once more. Thus, he would naturally delay as long as possible the decisive act of beginning.

At last, however, he pulled his easel into position and placed in front of it a small stool, carefully adjusting the front legs to red marks painted

* *Elie Lotar, the photographer.*

on the concrete floor of the studio. There were similar marks for the front legs of the model's chair, which he instructed me to set in place with equal precision. Then came the moment for selecting a canvas. Four or five fresh canvases were on hand and he examined each carefully. Then he went on to inspect every single painting in the studio, some twelve or fifteen pictures, muttering irritably, complaining that they took up too much room, and pushing them about. Finally, however, he selected a fresh canvas and placed it on the easel. Beside his own stool he placed another stool which held a clutter of old brushes and a small dish. From a quart bottle he poured so much turpentine into the little dish that it overflowed and some of the turpentine dripped onto the floor. Then he took his palette and a bunch of brushes and sat down.

He was seated so that his head was some four or four and a half feet from mine, and at a 45° angle to me, with the canvas directly in front of him. He did not indicate what pose I should take, but he did ask me to face him directly, head on, eye to eye, and frequently during the sittings he would say, "Look at me!" or "Let's see you!" or simply "Hey!" which meant that I was to look him straight in the eye. I did not cross my legs, as his models have often done, because I was afraid they might go to sleep. I left them spread apart, with my feet under the chair, and my hands seemed naturally to fall between them.

He looked at me for a minute before beginning to paint, then said, "You have the head of a brute."

Surprised and amused, I replied, "Do you really think so?"

"And how!" he exclaimed. "You look like a real thug. If I could paint you as I see you and a

policeman saw the picture he'd arrest you immediately!"

I laughed, but he said, "Don't laugh. I'm not supposed to make my models laugh."

Then he began to paint, holding his long, fine brush by the end and almost at arm's length, dipping it first into the dish of turpentine, touching it to one of the blobs of paint on his palette, then moving it over the canvas. He painted only with black at first. As he worked he looked at me constantly and also at everything around me. What he was painting obviously included his entire field of vision. He never made more than four or five strokes of the brush without looking at me, and now and then he would lean back from the canvas, squinting through his glasses, to study it for a moment. As he worked he lit cigarettes often, holding them in his left hand, which also held the palette and brushes, taking a puff only occasionally, finally dropping the butts on the floor. While he painted he talked and his somber humor seemed to disappear for a while.

We talked about his trip to London, where he had gone with his wife, Annette. He mentioned how much he had enjoyed seeing his friend David Sylvester, the critic, and also the painter Francis Bacon, whose humor and intelligence he appreciated highly.

"But I only had time to go to the National Gallery for half an hour," he remarked, "and I deliberately didn't look at the Rembrandts, because if I had looked at them I wouldn't have been able to look at anything else afterward. But I looked at that portrait of the old woman holding a rosary by Cézanne. He is the greatest. Also the van Eyck portrait of the man wearing a red turban. When he painted that picture, van Eyck

must have been farther away from his model than I am."

"I'd have thought just the contrary," I said, "because it's so detailed."

"Not at all," he replied. "If you were one foot farther away from me, your head would seem four times smaller than it appears now."

After half an hour Diego came in to say that Alberto was wanted on the telephone. He went out, and as soon as he'd gone I jumped up to have a look at what he had done. Using the fine brush and black paint as he would have used a heavy crayon, he had drawn the face, head and shoulders, arms, torso, hands, and legs. Except for background details, the portrait was complete. It was only a sketch, to be sure, but a sketch was what he had planned to do, nothing more. As such, it was finished, and I wondered whether he would leave it as it was.

When he came back, however, he sat down and started to work again without comment. Half an hour or more passed. Then he said, "Now it's beginning to look like something, only now."

In an effort to determine what he was doing and how the painting might be taking shape I watched carefully the brushes he used, how he moved them on the canvas, and what colors were employed: black, white, and a touch of ocher occasionally. But despite the fact that through the years I had often seen Giacometti paint, it was impossible to guess exactly what he was doing.

Presently he said, "We'll have to stop soon. I want to work on that bust. Then there are the figures, too. And tonight I have to work on the portrait of Caroline."

Caroline is a young woman who has for several years faithfully posed for him every evening.

I said that I was willing to stop whenever he

was, but he replied that he wanted to work just a little longer, because it was beginning to go well. "But I wish I had someone else to paint the clothes and backgrounds," he said. "Like Rubens. I hate having to cover the whole canvas. Besides, it's impossible ever really to finish anything."

A number of times he remarked that he was hungry, as he hadn't had anything but coffee since getting up several hours before. Again I suggested that we stop, but he refused.

"We can't stop now. I thought I'd stop when it was going well. But now it's going very badly. It's too late. We can't stop now."

Finally, though, he admitted that he was tired. His back ached. He had been working then for a little more than two hours. "That's enough," he said. Taking the canvas from the easel, he placed it at the back of the studio and moved away to study it. He had completed the drawing of the figure and had also sketched in the background: a tall stool to the left, the potbellied stove to the right, and behind me, the outlines of canvases propped against the wall. But he had also entirely painted the face and neck in black and gray. After studying the picture for several minutes he said, "The head isn't too bad. It has volume. This is a beginning, at least."

"A beginning?" I asked. "But I thought we were going to work only once."

"It's too late for that now," he said. "It's gone too far and at the same time not far enough. We can't stop now."

So I agreed to come and pose again on Monday. Then we went to the nearby café, where he ate what is his ritual lunch: two hard-boiled eggs, two slices of cold ham with a piece of bread, two glasses of Beaujolais, and two large cups of coffee.

"If only I could accomplish something in draw-

ing or painting or sculpture," he said, "it wouldn't be so bad. If I could just do a head, one head, just once, then maybe I'd have a chance of doing the rest, a landscape, a still life. But it's impossible."

I argued that what seemed impossible to him might seem to other people not only to have been possible—since, after all, it had been done—but fine and satisfying as well. That, however, was no consolation to him. The opinions of other people concerning his work, though of interest to him, are naturally unrelated to his own feelings.

"It's impossible to paint a portrait," he said. "Ingres could do it. He could finish a portrait. It was a substitute for a photograph and had to be done by hand because there was no other way of doing it then. But now that has no meaning. The photograph exists and that's all there is to it. It's the same with novels, because of the newspapers. A novel like one of Zola's would be absurd today, because any daily paper is infinitely more alive."

"What about Picasso's portraits?" I said. "All those drawings. You know them, Apollinaire, Max Jacob, Stravinsky."

"I hate them," Alberto said. "They're vulgar."

"But if you had to say which period of Picasso's you like best, which would it be?"

"None."

"What about the portraits he did of Dora Maar?"

"Those are caricatures of Van Gogh," Alberto said.

"But there have been portraits since Ingres," I insisted. "Cézanne painted some pretty good ones, of Gustave Geffroy and Joachim Gasquet, for example."

"But he never finished them," he pointed out. "After Vollard had posed a hundred times the most Cézanne could say was that the shirt front

wasn't too bad. And he was right. It's the best part of the picture. Cézanne never really finished anything. He went as far as he could, then abandoned the job. That's the terrible thing: the more one works on a picture, the more impossible it becomes to finish it."

Those were prophetic words. But I didn't know it then. I drank my Coca-Cola, said goodbye, and went off.

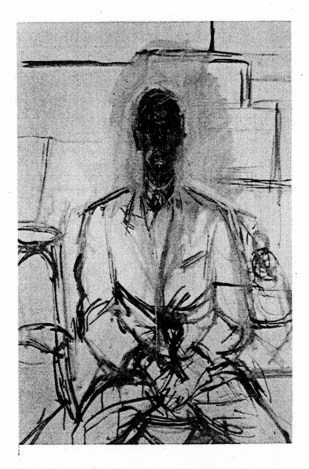

On Monday I arrived at the studio at about two-thirty in the afternoon. Giacometti had just gotten up. He was on his way to the café to have some coffee and I went with him. The café has come to be something of an adjunct to his studio and while we were there several people came to see him.* They returned with us to the studio. Beyeler saw the painting in progress and said he thought it

* *An art dealer from Basel named Ernst Beyeler and the photographer Franco Cianetti from Milan.*

superb. "Just wait," Giacometti warned. "I'm going to wreck it now."

By the time we were alone, it was four o'clock. The canvas was set on the easel, his stool and my chair were carefully placed in position, and work began. Before long he said, "It's impossible. I don't know how to do anything. I'll tell you what: I'm going to work on this picture for another day or two, and then if it doesn't turn out to be any good I'll give up painting forever."

Often in the past I had heard him say such things. I understood that in order for him to be able to see what was before him vividly and as though for the first time, it was necessary at any given moment for him to doubt his ability and to call into question not only what he was doing then but everything he had ever done. Although I had known Giacometti for a long time and he had in the past made a number of drawings of me, I realized that it was essential for him now to be able to see me as though I were a total stranger.

Some time passed. He was called to the telephone. While he was gone I stood up to look at what he had done. All the definition and volume of the head had disappeared; it seemed to be lost in a sort of gray nimbus. When he came back, he said, "It's going badly, but that doesn't matter, since there's no question of finishing it anyway."

"I'm sorry to make you work so hard for nothing," I said.

"Oh, but it's useful to me," he answered. "Anyway, this is what I deserve for thirty-five years of dishonesty."

"What do you mean?" I asked.

"Simply that all these years I've exhibited things that weren't finished and never even should have been started. But on the other hand, if I hadn't exhibited at all, it would have seemed

cowardly, as though I didn't dare to show what I'd done, which was not true. So I was caught between the frying pan and the fire."

"Not very pleasant," I observed, adding that many people might in similar circumstances have preferred some less difficult way out. This led us to talk of neuroses, which reminded me of someone I knew who shortly before had tried to kill himself. I mentioned it, then asked, "Have you ever thought of suicide?"

"I think of it every day," he replied, adding hastily, "but not because I find life intolerable, not at all, rather because I think death must be a fascinating experience and I'm curious about it."

"I'm not *that* curious," I said.

"Well, I *am*," he countered. "The most definitive, courageous way of killing oneself would be by cutting one's throat from ear to ear with a kitchen knife. That would really be taking things into one's own hands. But I'd never have the courage to do that. Cutting one's wrists is nothing. And taking sleeping pills is hardly killing oneself at all. It's simply going to sleep. But *the* thing, *the* suicide that really fascinates me is burning oneself alive. That would be something. And I thought of it long before those Indochinese monks started to do it. As a matter of fact, for months I was constantly talking about the possibility of burning myself alive at four o'clock in the morning on the sidewalk in front of the studio. Annette finally became so exasperated with such talk that she said, 'Do it or shut up!' So I had to stop talking about it," he commented rather wistfully. "The terrible thing about dying is that you can only do it once. I've also been rather attracted by the idea of being hanged. A beautiful, strong rope around the neck, that's attractive. Or, better still, to be hung by a rope around one's wrist till one died.

That would be pretty good, too. Very painful," he said with something almost like relish. "How long do you think it would take to die that way?"

"Four or five days," I said, "because you'd really have to die of thirst and hunger."

That left him pensive. "But I'm not at all afraid of pain," he said after a moment. "However, having one's fingernails ripped off one by one *would* be pretty unpleasant. But one would be sure to faint after the first two or three, or even after the very first."

"But one would revive," I said, "and then the process could be resumed till all the fingernails were gone." This idea did not appeal to him at all, which is understandable enough, if for no other reason than that his fingernails are very important to him in his work, scratching and gouging out globs of clay.

To someone who did not know Giacometti, such talk might seem either morbid or affected or both. It is neither. It is simply an expression of his perpetually restless and far-reaching curiosity. In this particular instance he was deeply concerned about the potentialities and significance of the physical facts of dying and pain. More than with most people, it is necessary to be face to face with Giacometti in order fully to appreciate the tenor of his conversation. His extraordinarily mobile and expressive features add to what he says a subtlety that sometimes conveys more meaning than the words themselves. For instance, while we were talking about the possible ways of killing oneself he smiled quizzically now and then, which I took to mean that although he was speaking seriously, at the same time he assumed that I understood the conversation to be without any purpose beyond itself and consequently an "amusement."

From death to war was an easy, obvious step, and our conversation took it. He began to tell me

about his experiences at the beginning of the Second World War, when the Germans had broken through the French lines and were approaching Paris. "It seems incomprehensible now," he said, "but as the Germans came nearer and nearer, a great many people decided to flee toward the south. There was an exodus. The roads were clogged with people using every imaginable sort of conveyance. Diego and a friend of his and I set out on bicycles. But there were German planes bombing and strafing the roads. Now, people had always thought of me as a person who was easily frightened. And I had always thought of myself that way, too. The first time the planes came over, bombing and strafing, and everybody jumped into the ditch, I was really frightened. But the second time I wasn't frightened at all, not at all. It's rather strange. It was a beautiful afternoon. There had been a storm, the sky was still full of huge clouds, though the sun had come out again, and you could still hear occasional rumbles of thunder in the distance. And as I lay there, looking up at the sky, with other people all around me in the ditch and a machine gun firing at the planes from under a nearby tree, I realized that I wasn't afraid in the least. It was the presence of the others in part, and in part the beauty of the afternoon that gave me courage. But I remember thinking that if anyone were to be killed I'd just as soon it should be me as one of the others."

"But if you'd actually had to choose," I said, "you probably would have chosen one of the others."

"Not at all," he responded. "It made no difference to me at all. Anyway, I didn't have to choose. The German army caught up with us at Moulins. We sat in a café and watched the soldiers go by. It was like a big party and everyone thought the

Germans were very nice. But I, with my exceptional intelligence"—he smiled ironically—"realized that it was essential to get back to Paris as soon as possible. So we pedaled furiously and made it in four days. All along the way we passed advancing columns of Germans and I remember realizing then that the Germans had lost the war. It seemed that they were winning at the moment, but that they could have won in the long run would have seemed to me no more extraordinary than to see a tree growing with its branches in the ground and its roots in the air."

At about six o'clock he asked if we couldn't stop for a few minutes. At seven, he explained, he was expecting a dealer who had acquired some early drawings and watercolors and wanted to exchange them for more recent, more salable drawings. In order to have it off his mind, he wanted to make the selection at once of possible material for this exchange. So we looked through all the portfolios and between us selected twelve or fifteen drawings. He complained that it was a nuisance for him to have to cope with such matters. At the same time, however, I felt that the prospect of what would undoubtedly turn out to be some rather mundane haggling did appeal to him.

As soon as the drawings had been selected, we went back to work. He announced almost at once that things were going badly. "It's going so badly that it's not even going badly enough for there to be some hope." But he continued, obstinately working till it was almost dark, concentrating his attention entirely on the head. When he stopped at last and the lights were turned on, I saw that the head had become more elongated and vaguer than the day before, crisscrossed by black and gray lines and surrounded by a sort of halo of undefined space. After the first sitting there had

been some semblance of a likeness. Now there was none at all. Not that that was a criterion, but I couldn't help feeling that the change had not been for the better, though I supposed it was only temporary.

"There's been progress," he said. "But we have to go further. We'll work tomorrow, won't we?"

"Sure."

Then the dealer arrived. Giacometti had to go into his bedroom to wash his hands and I went with him. He smiled conspiratorially and seemed most amused by the coming interview. While it went on, I talked with Diego. After half an hour or so, Alberto appeared, quite pleased with himself, announcing that he had obtained two early watercolors and two early drawings in exchange for four recent drawings. We went to his studio to look at them. One of the drawings and both the watercolors were landscapes, while the second drawing was a superb study of a nude woman. "It's the only one I did from life in 1935," said Alberto, "whereas the drawings I gave in exchange are just like hundreds of others I've done." He was very amused by the idea that most dealers are anxious to acquire only what will sell.

We went back to Diego's studio to see the work he had been doing, a pair of slender plaster hands joined together to form a small dish, very simple and graceful. Alberto admired the object, murmuring to me, "Oh, Diego has talent to burn."

Then we went together to the café, stopping on the way for Alberto to buy the evening papers. I left him sitting alone at a table on the café terrace, hunched over, not reading his papers but gazing off down the street, a solitary gray figure in the early evening, and I thought that none of the people passing by had any idea who he was and that he certainly preferred it so.

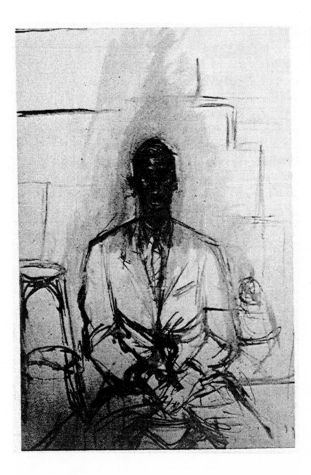

Several people were in the studio when I arrived the following afternoon. Now that Giacometti has become famous, in the sense of being a celebrity, he has far more visitors than he used to have. Ten years ago it was rare to find him busy with journalists, foreign dealers, museum curators, critics, collectors, and the curious. Now it is commonplace. He has accepted the change with calm, though the continual demands on his time often exasperate him.

It was four-thirty before we were able to start work. As he began to paint he said, "I've noticed that not only do you look like a brute full face but your profile is a little degenerate." He laughed broadly and added, "Full face you go to jail and in profile you go to the asylum."

We both laughed. Although he was capable of making jokes, at the same time he seemed overcome with dismay at the magnitude of the not-at-all-amusing task he had undertaken. He kept murmuring half to himself and half to me how impossible it was.

"I've been wasting my time for thirty years," he said. "The root of the nose is more than I can hope to manage."

However, he kept on working. The afternoon passed slowly. He smoked cigarettes and told stories of people he had known and of incidents that had either amused or interested him. But always he returned to the intolerable difficulty of the task at hand. I tried to deduce from the movements of his brushes what form the painting might be taking, but it was impossible. Sometimes he would sit hunched over for a minute or more, his head and hands hanging toward the floor in an attitude of absolute dejection, as though no hope whatever remained even for life itself.

"It's impossible," he murmured again and again. "I'll never find a way out."

At times his gloom was contagious. Sitting there in that gray, cluttered, dusty studio hour after hour, one began to feel that, indeed, the entire future did depend on the possibility of reproducing exactly by means of brushes and pigment the sensation of vision caused by a particular aspect of reality. This, of course, is by definition an impossibility and yet for that very reason is endlessly enticing and valid. Adding to the model's

sense of helplessness, although of essential impor-
tance to the work, was the demand for relative
immobility. Sometimes he would say, "You've
moved. Raise your head a little." And then some-
times, after I'd raised my head, he would say,
"No, no, you were all right before. Lower it
again."

After about two hours of work that afternoon
we had to stop because a publisher came to see
him. The painting was removed from the easel.
All the vagueness of the day before had disap-
peared. The head was precise and strongly mod-
eled but quite black. The body had acquired a
greater feeling of volume and some of the back-
ground had been painted in.

"Is it worth going on with?" Giacometti asked.

"Of course," I said.

"Is it out of charity you say that?" he half jok-
ingly inquired. "If so, it's a lousy trick. A real
friend would tell me I ought to give up painting
forever."

The publisher, who had been studying the pic-
ture, said, "It's superb. The way the image seems
to come and go is really vertiginous."

"What's vertiginous," Giacometti responded,
"is that it's not even a beginning and never will
be."

"For you perhaps," I said, "but not for us."

"Tomorrow we'll see," he replied.

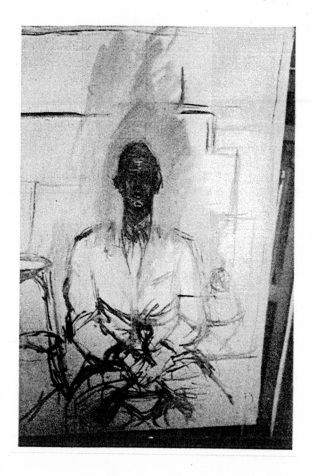

When I arrived the next day, he was working on a new bust of Diego, from memory now rather than from life. He said hello but continued to work, hardly glancing at me. I sat down on my chair. After a little while he asked, "What time is it?"

"Four o'clock."

"Damn! Already? I want to go to the café and drink something before we start to work."

"All right."

He left the studio and went to speak to Diego

for a moment, then came back and began to work on the bust again. I said, "Shall we go to the café?"

"Yes, let's go. Anyway, we can't work for very long today, because someone is coming at six." He continued to work on the bust.

"Let's go then," I said.

"All right. All right. Yes, we'll go." He took a rag and hurriedly wiped the clay from his hands, turned round and began to work on one of the tall figures. I didn't say anything. After a few minutes he said, "I can't tear myself away."

"So I notice!"

But finally he stopped, wiped his hands again, and we started out for the café. "I'm not so tired today," he said in the street, "but I'm in a foul humor. I think I'll give up painting for good."

In the café, however, the juke box and a conversation about politics cheered him somewhat.

We went back to the studio. He at once began to work on the bust again. I placed the easel, the stools, the chair in position, put the canvas on the easel, and sat down to wait. He murmured irritably to himself. Ten minutes passed. At last, with obvious reluctance, he turned away from the bust and sat on his stool. "It's impossible," he declared, "particularly at this distance. It's impossible." But he began to paint nevertheless.

"The funny thing is," he remarked after a time, "that I simply can't seem to reproduce what I see. To be able to do that, one would have to die of it."

To him the predicament was not at all amusing. When he spoke of dying, it seemed that he actually believed it. And yet he worked on. This is the essential, unbearable duality of his life.

"There," he murmured presently, "the nose is in place now. That's some progress." | 23

Before long, he complained that he was growing tired and that there were pains in his back. He had slept badly the night before, he said. But he wouldn't stop. He couldn't. "I know where I'm going now," he said. "I see how I can advance things a bit."

When he was finally willing to stop, the painting had made a real, very perceptible progress, though only the head had changed. It was more erect and delineated now, with a greater feeling of perspective and volume. Even he was prepared to admit that there had been progress. "But it will be better tomorrow," he insisted. "Tomorrow we'll really begin."

"All right," I said. "But we'll have to talk about my departure, too. I hadn't expected to stay in Paris even this long, you know, and I've already changed my reservation twice."

"Well, when are you leaving?" he asked.

"At the end of the week, supposedly. But I could put it off again. I just want to know how long, that's all."

"I'd like to work another week."

"Then I could leave next Wednesday, say, one week from today, couldn't I?"

"Yes. But it doesn't really matter, because there's no question of finishing the picture, anyway. I'll give it to you, though. Not immediately but eventually. I'll have to have it around for a while to see how it looks in relation to everything else. But you can have it when I don't need it any more."

"Thank you," I said.

He shook his head. "Maybe it won't be worth having," he said.

By that time it had become clear that his entire attention, and work, was concentrated on the head. Indeed, if he worked on the rest at all, it | 24

was only in order to situate the head in relation to the canvas as a whole, not because he expected eventually to complete the entire figure. He painted the head over and over. Before his eyes the image must have come and gone much as the image seen through a camera lens may move in and out of focus.

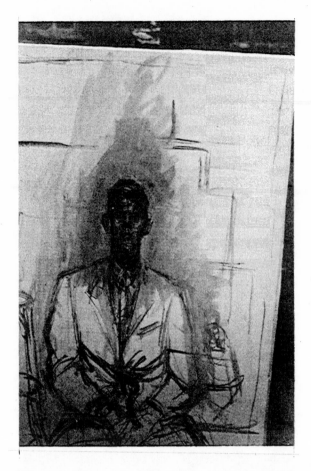

The next day was the fifth sitting. Only then did I begin to feel that both of us were really involved with the painting. It had gradually come to be Giacometti's principal preoccupation, taking precedence over the sculptures in progress and even over the portrait of Caroline on which he worked almost every evening.

After painting for a time that afternoon he said, "It couldn't be going worse. It seems impossible to do. And, after all, it would not be any better if

you were farther away. The distance between the artist and the model doesn't matter. A head is simply impossible to paint. A hand would be much easier."

"Why?" I asked.

"A hand is merely a spatula with five cylinders attached to it."

"That depends on how you do it," I said.

"Of course. Rodin did fantastic hands."

Later he asked, "Do you mind doing this?"

"Not at all," I replied. "In fact, I like it."

"So do I. When I was young, I used to pose often for my father and I liked it very much. Besides, you're free to stop whenever you want to."

"So are you."

"Yes. Both of us are free. But it would be better if I knew how to do something."

This constant expression of self-doubt is neither an affectation nor an appeal for reassurance on his part but simply the spontaneous outpouring of his deep feelings of uncertainty as to the ultimate quality of his achievement. In order to go on, to hope, to believe that there is some chance of his actually creating what he ideally visualizes, he is obliged to feel that it is necessary to start his entire career over again every day, as it were, from scratch. He refuses to rely on past achievements or even to look at the world in terms of what he himself has made of it. This is one reason why he often feels that the particular sculpture or painting on which he happens to be working at the moment is that one which will for the very first time express what he subjectively experiences in response to an objective reality.

When he had painted for an hour or more, we rested for a while. That is, I stretched my legs, while he immediately started working again on one of his sculptures.

"My taste gets worse every day," he said. "I've been looking at a book in which paintings are reproduced next to photographs. There was a portrait by Fouquet next to a photo of a real person, and I preferred the photo by far. Yet I like Fouquet very much."

I mentioned a painting by Matisse, a head and shoulders of a young girl, painted about 1942, which I had seen in Diego's house.

"I gave it to him," said Alberto. "It's a painting that I saw at Beyeler's gallery in Basel. All of Matisse seemed to me to be in that one painting, and it had been a very long time since I'd seen a painting that I really wanted to own. So Beyeler offered to exchange it with me for something of mine. But after four days I couldn't stand to look at it any longer, so I gave it to Diego."

We spoke of Velazquez, and Alberto said he preferred *The Weavers* to *The Maids of Honor*. He has never been to Spain, but he saw the pictures from the Prado when they were exhibited in Geneva just before the war.

"It seems to me that Balthus* has looked at Velazquez long and hard," I remarked.

"It's not apparent in his paintings," said Alberto. "I like Balthus and his work, but I don't see any relation to Velazquez."

"There's a great feeling of space in some of them," I said, "as there is in *The Maids of Honor*, and also the sense of space being enclosed in that big room."

"What I like about Balthus is his naïve side," Alberto observed.

"I wouldn't have said he was naïve. I'd have said on the contrary that he's very sophisticated."

"It's the same thing," Alberto stated flatly.

* *The contemporary painter, born 1908.*

When he started to work again on the painting, he talked for a time about Cézanne. "He was the greatest of the nineteenth century. He was one of the greatest of all time."

"Yes," I agreed. "But I wonder—not that it matters—whether he was someone we'd have liked to know. I don't think so."

"No," he said. "He was bigoted, bad-tempered, bourgeois. Like Rodin. Though the fact that he never finished his paintings, or considered them finished, is very appealing. He abandoned them. He just abandoned them. And there's another thing about him I like. In Cézanne's time the director of the Berlin museum, a man named von Tschudi, I think, had to submit all his purchases for approval to the Kaiser. Apparently the Kaiser automatically approved of everything—except impressionist pictures. Cézanne heard this and said, 'The Kaiser is right.'" Giacometti laughed.

After a time he said, "It's going very badly, my friend. But what does it matter? There's no hope of finishing it, anyway."

Diego came and called him to the telephone. It was Annette, calling from London, where she had remained a few days longer, to say she would be back the following day.

As the light faded in the studio, he worked on and on. It became grayer and grayer. I could no longer clearly distinguish the details of his head, which was wreathed in whorls of cigarette smoke. I remarked that with so little light he could hardly expect to see very well.

"For what I'm doing," he replied, "there's more than light enough." But at last he did stop. When the electric lights were turned on and we looked at the painting, he seemed pleased. He said, "I've never made so much progress in a single sitting."

Whether or not this was true I don't know, but certainly he had made more progress that day than on any of the preceding days I had posed. The face was less black now, the features more clearly drawn and vivid. The sense of space surrounding the head and shoulders had begun to acquire depth and expressiveness.

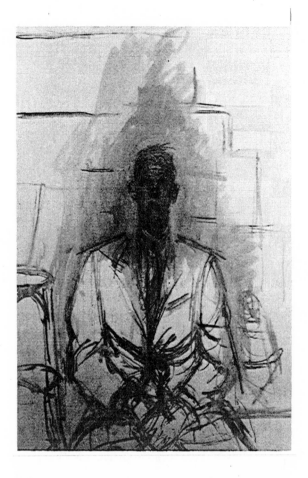

6

Alberto was not at the studio when I arrived there the next day. Diego told me that he had gone to Mourlot's lithography plant to examine the proofs of lithographs for the large folio which Tériade is to publish next year. It was about half an hour before he came back. He went directly into his studio without speaking to Diego or to me. When I went in after him, he was already in the far corner, busily going through the four or five large portfolios of drawings that are kept there. He paid

no attention to me, seemed unaware, in fact, that he was not alone. Impatiently he pulled from the portfolios a quantity of drawings on lithographic transfer paper, plus some blank transfer paper and a number of drawings on ordinary paper. All these he threw on the floor.

"What in the world are you doing?" I finally asked.

"I'm going to junk this stuff," he said.

"No!" I protested.

"Yes!" he exclaimed. "You'll see."

Snatching the pile from the floor, he went out with it into the passageway, where there is a trash can near the door to Diego's studio. He threw all the drawings to the ground, took a handful and began to tear them to pieces. I caught his arm and tried to stop him. "Wait a minute," I argued. "Let's look them over first."

"No, no," he cried, taking another handful and tearing it up.

Obviously there was nothing I could do. And, after all, the drawings were his to destroy if he wished. However, I know him and have had at least one similar experience with him in the past. So I snatched a couple of drawings from the top of the pile and went back to the studio. He did not return at once. He was talking with Diego. I set up the easel, placed the painting on it, put the stools and the chair in their respective places, and waited. Presently he returned, seemingly quite calm. I asked why he had destroyed all those drawings, some twenty-five or thirty at least. He explained that at Mourlot's he had discovered that the lithographic transfer paper he'd been using was too old and would no longer transfer to the stones properly. Consequently he had wanted to get rid of whatever drawings could not be transformed into the lithographs he had intended them

to be. He was obviously very annoyed by this technical contretemps. I protested that he need not have destroyed the drawings, which had been valid as drawings whether they were transformed into lithographs or not. But he would hear none of that. He had wanted to be rid of them and that's all there was to it. His feeling seemed to be almost one of spite, as though the drawings themselves had offended him and he wanted to revenge himself on them. I reminded him that he had also destroyed a number of drawings on ordinary paper. "It doesn't matter," he said. "They were no good, anyway. I'm glad to be rid of them." Apparently it was neither here nor there that he had barely glanced at them as he pulled them out of his portfolios. I didn't insist, but I was reminded of Cézanne's habit of furiously and indiscriminately slashing his canvases when dissatisfied with something he had done. The gesture was general, not specific.

He began to work. As usual, the head alone received his attention. By this time, I thought, he must have done it over at least twenty-five or thirty times. But after a while he said, "Everything must be destroyed. I have to start all over again from zero."

Later he referred once more to the book he had mentioned the day before which contained comparisons of photographs and paintings. On one page there was a Dürer, he said, also a portrait of a cardinal by Raphael, and a very academic portrait of Marshal Foch. He said he preferred the portrait of Foch. "Anyway," he added presently, "it's impossible to reproduce what one sees."

"But is even a photograph really a reproduction of what one sees?" I asked.

"No. And if a photo isn't, a painting is even less so. What's best is simply to look at people.

Besides, it's impossible to achieve a likeness. For example, when I made that sculpture of the cat, I didn't make it a likeness, because I'm incapable of doing that."

"How did you happen to make the cat?" I asked.

"I'd seen that cat of Diego's so often coming across the bedroom toward my bed in the morning before I got up that I had it in my mind exactly as it is. All I had to do was make it. But only the head can even pretend to be a likeness, because I always saw it head on, coming toward my bed."

"The dog," I said, "is much more of a likeness than the cat."

"The muzzle, yes, but not the back legs at all. The back legs are utterly false."

"How did you happen to make the dog?"

"For a long time I'd had in my mind the memory of a Chinese dog I'd seen somewhere. And then one day I was walking along the rue de Vanves in the rain, close to the walls of the buildings, with my head down, feeling a little sad, perhaps, and I felt like a dog just then. So I made that sculpture. But it's not really a likeness at all. Only the sad muzzle is anything of a likeness. Anyway, people themselves are the only real likenesses. I never get tired of looking at them. When I go to the Louvre, if I look at the people instead of at the paintings or sculptures, then I can't look at the works of art at all and I have to leave."

Apropos of Annette's impending return from London, we came to talk of geography, Europe, the six continents, and, finally, of Japan. I remarked that I had never known well either a Chinese or a Japanese, whereas he had been very friendly over a period of several years with Isaku Yanaihara, the Japanese professor who had posed

during that time for a quantity of paintings and sculptures. I wondered whether he had ever felt aware of any difference between himself and Yanaihara, any fundamental disparity in their instinctive attitudes or reactions, a disparity which might have been due to the unlike background, nationality, and race.

"Absolutely none," he said. "He seemed just like me. In fact, I came to accept him as the norm because I was with him so much. We were always together: in the studio, at the café, at the Dôme and the Coupole, in night clubs. We were together so much that one day I had a curious experience because of it. Yanaihara was posing for me and suddenly Genet came into the studio. I thought he looked very strange, with such a round, very rosy face and puffed lips. But I didn't say anything about it. Then Diego came into the studio. And I had the same feeling. His face looked very rosy, too, and round, and his lips looked very puffy. I couldn't understand why. Then suddenly I realized that I was seeing Diego and Genet as they must have looked to Yanaihara. I had concentrated so long and so hard on Yanaihara's face that it had become the norm for me and during a brief moment—it was an impression that lasted for only a very little while—I could see white people the way they must look to people who aren't white."

When Giacometti told stories of this kind, and others that were sometimes much longer and far more personal, he seemed completely absorbed in what he was saying, he spoke rapidly and apparently forgot about the painting, though he always continued to work on it. He obviously enjoys talking with his model. On one occasion, when he was talking so much that I thought it might interfere with the progress of the painting, I suggested that

he keep quiet for a while. He said, "It's hard for me to shut up. It's the delirium that comes from the impossibility of really accomplishing anything." When he is not painting, however, and, for instance, sitting with someone in a café, it is not at all unusual for him to remain silent for long periods of time, staring into space. But to talk to his model while he is working distracts him, I think, from the constant anxiety which is a result of his conviction that he cannot hope to represent on the canvas what he sees before him. This anxiety often bursts forth in the form of melancholy gasps, furious expletives, and occasional loud cries of rage and/or distress. He suffers. There is no doubt of it.

Jean Genet has written that Giacometti tends to develop emotional relationships with his models, almost romantic feelings for them. This may in part be a projection of Genet's singular subjectivism, yet I believe there is some truth in it. And in my case at least, the feelings were reciprocal. It is not surprising that such feelings should exist. Giacometti is committed to his work in a particularly intense and total way. The creative compulsion is never wholly absent from him, never leaves him a moment of complete peace. I remember his saying a number of times that when he wakes up in the morning the very first thought that comes to his mind is of the work waiting to be done, the paintings and sculptures that he may have en route—to use his own expression—at the moment. With this thought, he says, always comes a nightmarish sensation of hopelessness, of having his face pressed against a wall and being unable to breathe. In the same spirit he sometimes talks wistfully of the time when he will be able to stop working forever, when just once he will have suc-

ceeded in representing what he sees, in conveying tangibly the intangible sensation of a visual perception of reality. This is, of course, impossible, and he must certainly know it. The very measure of his creative drive is that he should longingly dream of someday being free of it. This intensity naturally communicates itself to those around him, and most immediately to those closest to his world, who are at any given moment his models. That they should almost always have been people close to him—his wife, his brother, and personal friends of long standing—is no accident, I think. The experience of posing for Giacometti is deeply personal. For one thing, he talks so much, not only about his work but also about himself and his personal relationships, that the model is naturally impelled to do likewise. Such talk may easily produce a sense of exceptional intimacy in the almost supernatural atmosphere of give and take that is inherent in the acts of posing and painting. The reciprocity at times seems almost unbearable. There is an identification between the model and the artist, via the painting, which gradually seems to become an independent, autonomous entity served by them both, each in his own way and, oddly enough, equally.

This sense of identity is illustrated by two incidents that occurred while I was posing. One day his foot accidentally struck the catch that holds the easel shelf at the proper level, causing the canvas to fall abruptly a foot or two. "Oh, excuse me!" he said. I laughed and observed that he'd excused himself as though he'd caused me to fall instead of the painting. "That's exactly what I did feel," he answered.

Another time the left side of my face began to itch violently. Since he desired complete immobil-

ity, I tried to relieve the itch by twitching my cheek and nose instead of raising a hand to scratch.

"What's the matter with you?" he asked.

"My face itches," I explained.

"Why?"

"Because of all the little strokes of your brush on my cheek."

He laughed. "Very pretty," he said.

I laughed, too, and scratched my face. But what I had said was absolutely spontaneous and unpremeditated, not at all an effort to make a pretty phrase. I told him this and he said that he understood perfectly the sense of transmutation my remark implied.

It is often said that artists of great talent are able, and seek, to convey not only the external appearance but also the inner nature of their models. I do not know whether this is so but it would not seem surprising that a portrait should reflect the exceptional intimacy that may grow between an artist and his model. The creative instinct, after all, acts at the bidding of the unconscious, which also decides to a considerable degree the exact nature of human relationships. But Giacometti did not feel that any rapport whatever existed between a portrait and the individual nature of the model. Not in his work, in any case. "I have enough trouble with the outside without bothering about the inside," he said.

While I was posing, he occasionally asked me whether I was tired of it. "Is this getting on your nerves?" he would inquire. I don't think he meant the physical act of posing but rather the entire experience and in particular my inevitable, though indirect, participation in his moments of doubt and despair. In answer to such questions I always said no, which was in substance a truthful answer,

for the entire experience was an exhilarating one. Yet there were moments when I found it psychologically exhausting to be the pretext, as it were, for an effort that acknowledged in advance its own futility but which at the same time insisted that nothing was more valid than to make the effort anyway. This fundamental contradiction, arising from the hopeless discrepancy between conception and realization, is at the root of all artistic creation, and it helps to explain the anguish which seems to be an unavoidable component of that experience. Even as "happy" an artist as Renoir was not immune to it. But it has seldom been expressed with as much lucid and unrelenting singleness of purpose—both in his life and in his work—as by Giacometti. This is in part what has prompted some critics to describe him as an "existential" artist.

There are certain images that recur regularly throughout Giacometti's work. Of these, the most salient has certainly been the head of Diego, which has come to seem almost an archetypal visage of man. I mentioned this to Alberto, and he replied, "That's normal. Diego's head is the one I know best. He's posed for me over a longer period of time and more often than anyone else. From 1935 to 1940 he posed for me every day, and again after the war for years. So when I draw or sculpt or paint a head from memory it always turns out to be more or less Diego's head, because Diego's is the head I've done most often from life. And women's heads tend to become Annette's head for the same reason."

He recalled again how the constant posing of Yanaihara had caused him to see Diego and Genet in such an unaccustomed way, and said that for some time afterward he had found it difficult to recognize people and had even occasion-

ally confused them with one another. "Besides," he added, "at times I have the feeling that one human face is barely different from all the others. One blonde, for instance, is just as good as another. I once said that to a blonde I know, and she didn't like it at all. But there are very little differences between people. For instance, what causes me to recognize you in the street?"

"The ensemble?"

"Yes, but not any single detail. Details are unimportant in themselves. What causes one person to seem attractive to another?"

"I don't know," I replied. "But I'm sure it has nothing to do with being good-looking in the conventional sense."

"Of course not."

The painting was confused and vague when we finally stopped work that evening. The mouth had become lopsided, the transition between jaw and neck was formless. He was not at all pleased. "It's because we talked too much," he said. "Tomorrow we'll work seriously."

Just before leaving I said to him, "I've got a present for you." And I handed him the two drawings I had saved from destruction earlier in the afternoon.

He looked at them curiously. After a moment he smiled and said, "You did right. They're not bad. Put them in the portfolio over there."

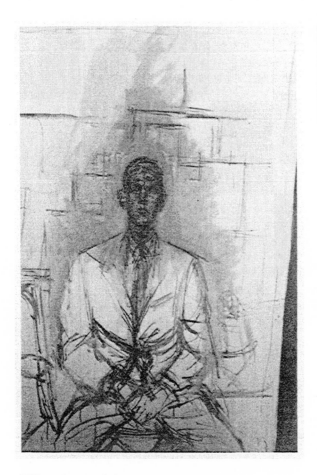

When I arrived the next day, I said, "Today we're going to work seriously and not talk too much."

"We won't talk at all," he replied.

And for some time he did work in relative silence, interrupted only occasionally by the customary gasps and expletives. Finally, however, he said, "You aren't going to leave for the Americas, are you?"

"No," I said.

"I'm going to make serious progress with the

painting from now on, and I need you. But I'll pay you for posing."

"Are you crazy?" I exclaimed. "That's out of the question."

"Certainly I'll pay you," he insisted. "I have to pay you. I have to give you something, because the portrait will never be good enough to give you."

I said nothing.

He smiled slyly and after a moment added, "You must be thinking, 'What a dirty trick!' "

"No," I said, "that's not what I'm thinking at all. I'll tell you later what I'm thinking."

What I was thinking was that this was the first time in all the years I'd known Giacometti that I had ever had the feeling of being able really to do something for him, of being able to demonstrate in a tangible way my esteem and affection. He had been exceedingly generous to me, but I had never been able to give him anything that to me was an adequate expression of my friendship. Now I could. And, miraculously enough, I even seemed useful to him in his work, which was an unhoped-for satisfaction. When I tried to tell him these things, however, he would not listen. He is a person to whom anything even bordering on the effusive is distasteful. He expresses what he feels by doing something not by talking about it.

After working for an hour and a half we decided to take a break. He said, "I stopped five minutes too late. A little while ago it was good."

It was, in any case, better that it had been at the end of the previous day's sitting. The face was crisscrossed with black lines, but it had a fresh precision and solidity.

When we started work again, he kept insisting that my head was too far to the right or to the left, | 42

too high or too low. No matter how I moved it, it seemed to be wrong. Finally we looked at the legs of the chair and found that they were about half an inch off the red marks painted on the floor. But that made all the difference, he said. From that time on, he himself always carefully checked the position of the chair before he began to work.

Presently he started gasping aloud, with his mouth open, and stamping his foot. "Your head's going away!" he exclaimed. "It's going away completely."

"It will come back," I said.

He shook his head. "Not necessarily. Maybe the canvas will become completely empty. And then what will become of me? I'll die of it!"

There was nothing I could say, or do. To be present but helpless, to be involved but removed made me uneasy.

He reached into his pocket, pulled out his handkerchief, stared at it for a moment, as though he didn't know what it was, then with a moan threw it onto the floor. Suddenly he shouted very loudly, "I shriek! I scream!"

Startled, embarrassed, I laughed awkwardly.

"It's not very nice to laugh at the misery of others," he said grimly.

"That's true," I said. "Excuse me."

For a time he worked on in silence. Then abruptly he asked, "Have you ever killed any-one?"

"No," I replied. "Why do you ask me that?"

"Because I believe you're capable of anything," he said, smiling. "That's a compliment."

"Thanks. And you? Have you ever killed any-one?"

"Never."

Annette had returned from London the evening | 43

before. She came into the studio, looking very pretty in a mustard-colored coat. "It's very nice that you're posing in my place," she said to me.

"The painting is going worse and worse," he announced. "It's impossible to do it. Maybe I'd better give up painting forever. But the trouble is that if I can't do a painting, I can't do a sculpture, either. It's the same thing. Well, it's not exactly the same thing, but it's close to being the same thing."

"Why don't you work on the body or the background," I asked, "if you're having trouble with the head?"

"No, no," he said. "Everything has to come in its own time. If I paint in the body or the background just to be doing something, to fill in space, that would be obvious, it would be false, and I'd have to abandon the picture completely. No. Tomorrow it will come. I've reached the worst now. Tomorrow is Sunday. That's fine. The worst will be for tomorrow."

Toward the end of the sitting, as it began to get dark, he took off his glasses several times and stared away toward the other side of the studio as at nothing. I suggested that we stop for the day. "No," he said, "I'm just resting my eyes."

Finally it had grown so dark that we had to stop and turn on the lights. The portrait had progressed noticeably. Or so it seemed. To be certain from day to day of exactly what had happened, and to decide whether or not it really represented a progress, was sometimes very difficult for me. But Giacometti, in any case, was pleased. He said, "It did advance in spite of everything, didn't it?"

"Yes," I said, "it did."

Annette, too, felt that the work was progressing well.

Giacometti had to go to meet a journalist at the café. I stayed behind to talk for a while with Annette.

"How do you like posing?" she asked.

"Very much," I said. "But sometimes Alberto almost scares me, the way he yells when things aren't going well." Annette laughed at that. "But," I added, "what really disturbs me is the way the painting seems to come and go, as though Alberto himself had no control over it. And sometimes it disappears altogether."

Annette laughed again. "Oh," she said, "I've become so used to that that I simply don't notice it any more."

"But it could go on for months."

"Sometimes it does."

"And there's nothing anyone can do."

"No."

"Not even Alberto himself, I suppose."

"No," she said, "not even Alberto."

"Of course. It's strange, this feeling of fatality."

Annette shrugged. "You'll get used to it."

"Yes," I said, "I suppose I will."

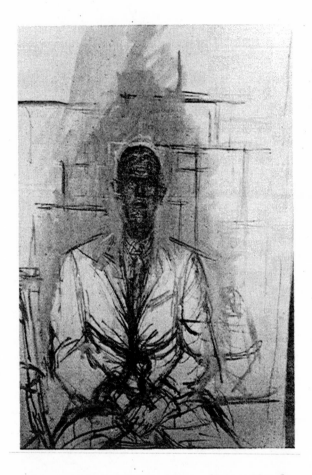

Giacometti looked forward to working on Sunday because the chances of being disturbed then by visitors were less than during the week. As soon as I arrived at the studio, he told me that he hadn't gone to bed till five and had slept very badly. But he denied feeling at all tired, and we began work at once. "It's going to go well today," he said. "There's an opening. I've got to make a success of the head." I didn't answer, and after a few minutes he added, "This morning when Diego

came into my room I was overcome by the construction of his head. It was as though I'd never seen a head before."

For some time he worked on. I inferred that the painting might be going well for once. Then he said, "Now I've got to undo everything. One should try to succeed in undoing everything and then doing it all over again very quickly, several times in the same sitting. I'd like to be able to paint like a machine."

We began to talk about painting in general, and once again I was struck by the detailed intimacy and great breadth of his knowledge. The pictures in the Louvre are as familiar to him as those in his own bedroom, and he remembers with precision paintings that he hasn't seen for thirty or forty years. On this particular day he mentioned Le Nain especially, saying that the paintings by him in the Louvre were to him among the most beautiful works there. "The figures in them express human feelings," he said, "and that becomes rarer and rarer in painting as we approach the present." I observed that Cézanne expressed much human feeling in certain of his pictures.

"Maybe so," he said, "but he does it in spite of himself, whereas Le Nain does it deliberately. That makes all the difference. As for me, I'm incapable of expressing any human feelings at all in my work. I just try to construct a head, nothing more."

"That isn't everybody's opinion," I said. "In some of your sculptures and paintings I find a great deal of feeling."

"You may find it," he said, "but I didn't put it there. It's completely in spite of me."

"But what you may think of your work," I said, "while it's important to you, is not neces- | 47

sarily important to other people, or even necessarily the truth."

He shrugged. He was painting. Speculation meant nothing then, though at other times he indulges in it with relish.

Toward six o'clock we stopped for a rest. The portrait looked fine, I thought, and said so. "It will be even better later on," he said. He worked at his slender figure while I walked up and down and rubbed my behind. Nodding at the sculpture, he said, "I'm doing something here that I've never done before. It may not be apparent to you, but I am."

It was not apparent to me. The figure looked very much like a number he had done in the past. But the point, I thought, was that his feelings in relation to it were unlike any he had had before. To him the plastic problem, the visual response to reality was utterly new, because he possesses the rare capacity of seeing a familiar thing with the intense vividness of a completely new sight. And it is this extraordinary, though taxing, ability which enables him to imbue with fresh vitality subjects he has treated numerous times before, and which enabled him to paint my head over and over in the fervent hope that he would eventually be able to reproduce it exactly as he saw it.

After a time he transferred his attention to the bust of Diego. He remarked that recently he had somewhere run into Malraux, who asked him what he was doing. Alberto had replied, "I'm doing a head."

"What monstrous pride!" said Malraux, who went on to remark that there were, to be sure, Egyptian heads, Sumerian heads, Chinese heads, Romanesque heads. And Gothic heads, Malraux had mused aloud, were there really any Gothic

heads? But just then someone had come along and drawn him aside.

"So we'll never know if there are really any Gothic heads," Giacometti observed. "But for me, anyway, the best contemporary heads are painted by the people who do those huge heads for movie posters. They must work from photographs, though. Otherwise, they could never accomplish what they do."

When we resumed work on the painting, he immediately announced that it was again going very badly indeed. He said that that morning, as usual, he had had his familiar nightmarish awakening, accompanied by the realization that he couldn't ever possibly hope to achieve his ambition: to paint what he saw. "If only someone else could paint what *I* see," he said, "it would be marvelous, because then I could stop painting for good."

"Considering the low opinion you're always expressing of your own work," I said, "it would interest me to know what you think of all the people who admire it. Like me, for instance."

"When I see an exhibition of my own things," he replied, "as at the Maeght Foundation, for instance, I'm the first to think that they're better than what anyone else does. But then I realize that that has absolutely no relation to what I hope to be able to do, so I conclude that really they're no good at all."

"Well," I said, "it's a good thing that everyone doesn't see them the way you do."

"I couldn't care less," he responded.

The work continued to go badly. He gasped and muttered to himself. Finally I said, "Why don't we stop for the day? Shall I stand up?"

"Yes," he replied, "and put me out of my mis- | **49**

ery." But he quickly added, "Don't move! I was only joking." So I stayed where I was.

Presently he asked, "You aren't leaving tomorrow, are you?"

"No."

Then once again he said that he would pay me to stay on. And when I answered that any such arrangement was out of the question, he said, "Anyway, the painting is yours."

I tried to thank him, but he impatiently dismissed my efforts.

It began to get dark. Several times I suggested that we should stop. But he always insisted that he needed a few more minutes of work. Annette had come into the studio a little while before, and she said, "He always likes to work a little while in the dark."

Then Diego came in. He said to Alberto, "What are you doing?"

"I'm working," Alberto replied.

Diego laughed. "It's dark. You can't see a damn thing."

I stood up then. The lights were turned on. Half of the afternoon's work had disappeared into a gray vagueness. It was somewhat discouraging. I had by then become so involved in the metamorphoses of the painting and so identified with it, not only as my portrait but also as the focus of my daily life and my sole reason for remaining in Paris, that I felt rather depressed to have it apparently retrogress. But Giacometti insisted that real progress had nevertheless been made, and that even more progress would surely be made the next day. And, after all, I thought, he saw it in a truer way than I could, because he saw not only where it was but also where it was going.

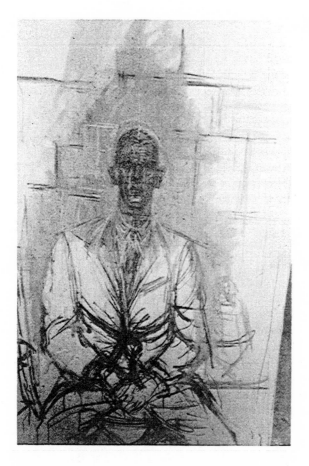

The following day was the ninth on which I had posed. I was beginning to be able to determine what Giacometti was doing while he worked by observing the way in which he used his different brushes and by watching which colors he used and when. Although he always held a bunch of eight or nine brushes, he never used more than three: two fine ones with long, thin, supple tips of sable hair and one larger one with a much thicker, shorter, and stiffer tip. One of the two

fine brushes was used with black to "construct" the head, building it up gradually by means of many small strokes on top of each other. After working for a time in this way, he would dip the brush into his dish of turpentine and squeeze the tip between his fingers. Then he would begin to work with the same brush again but using white or gray pigment. From this I deduced that he was beginning to develop the contours and volume of the head and to add highlights. Before long, he would take the other fine brush and begin to work over what he had already painted, but using white pigment only. When this happened, I knew that the head would soon enter the "disintegration" phase. Then, after a time, the large brush would be brought into play, handled in a much more free and sweeping way than the fine ones. It served to form the space behind and around the head, to develop the contour of shoulders and arms, and, finally, to complete the gradual process of "disintegration" by painting out details. Then, with the first of the fine brushes, he would begin once more with black pigment, to try to draw from the void, as it were, some semblance of what he saw before him. So it went on, over and over again.

That day, after he had worked for a time, he said, "I've got to square everything. Everything is a sphere, a cone, or a cylinder, it's true. Too bad I'm not the first to have made that observation. Cézanne was right. But the cubists were stupid enough to take him literally. For me, cubism was a perfectly stupid undertaking."

"And yet the cubists produced some very pretty things," I said.

"Yes," he agreed, "pretty is just the word. Anyway, they quickly realized that it was a dead end and gave up. For me the really guilty ones were Picasso and Braque, not the minor cubists

who followed. Then Picasso went on to do Ingres."

"His Ingresque things don't compare very well with the originals," I observed.

"No," said Alberto. "And after that he did Van Gogh."

"He's done everything," I said. "It reminds me of a story Dora Maar once told me. She said Picasso had said to her, 'Being unable to reach the top of the scale of values, I smashed the scale.' "

Alberto snorted. "That doesn't mean a thing. It's like all of Picasso's remarks. At first they seem full of wit, but in fact they're empty of meaning."

I went on to say that Dora had also spoken to me of a large portrait bust made of her by Picasso,* saying that Picasso had asked Alberto to criticize the bust while he was at work on it and had then modified it considerably as a result of the criticism. Alberto remembered the sculpture and having been asked to criticize it, but he said that instead of taking his advice Picasso had done the contrary.

Later he said, "If only I could find someone to do this in my place!" And when I didn't answer, he added, "The way I want it."

Laughing, I said, "That's not asking much."

He laughed, too. "If I could find someone else," he said, "to do it exactly the way I want it, then I'd be able to stop forever."

"But would you be satisfied to have it done by someone else, assuming, of course, you found someone to do it just the way you want it?"

"I'd be delighted."

After working for a little while in silence, he

* The one of which a cast is now in the little park next to the Church of Saint-Germain-des-Prés.

suddenly said, "The head isn't going well at all. It's lopsided now. Merde! And I don't seem to be able to get it straight again. Besides, the surface is so shiny with turpentine that I can't see a thing."

"Well, why don't you work a little on the rest of the picture?" I suggested. Though realizing perfectly well that it was alien to the spirit of his enterprise to expect him to "finish" the painting in a conventional sense, I nevertheless felt that if the rest of the picture were more fully realized, then the head in relation to it might seem to him less difficult to represent.

But he didn't feel that way at all. "It would be filling in for the sake of filling in," he said. "You can't fake a picture like that. Everything must come of itself and in its own time. Otherwise, it becomes superficial. As a matter of fact, we'll have to stop soon, because the head is beginning to be a little superficial right now. I'm tired, too. I have no reflexes left at all. But there's an opening in sight. There's hope. That's why I'm so tired."

"I'd have expected it to be the other way around," I said. "If there were no hope, I'd expect you to be tired."

"Not at all. It's like a person who's in great danger and has to exert an exceptional amount of physical strength to save himself. That's when the picture is going badly. But as soon as he has saved himself, or even sees a way out, he's utterly exhausted. I remember there was a man from Stampa who was climbing in the high mountains near there and fell onto a very narrow ledge. He managed to hold on until the rescue party was literally within arm's reach. Then he fell and was killed. Not that it's quite the same thing for me. I'm in no danger of dying, after all."

Presently we stopped to rest. I was very tired, | 54

too, more so than usual after only an hour and three quarters of posing. Added to the ordinary fatigue of remaining immobile for long periods of time, however, was the tension of the work itself, in which I seemed to participate more actively each day.

Alberto went to see Diego, returning after a few minutes with several letters and a small package wrapped up in tissue paper like a sandwich. He sat down on the bed and looked at the letters.

"What's in the package?" I asked.

He unwrapped it slowly. It was filled with money, at which he gazed with wonder and amusement, fingering it curiously. "Well," he said, "it's only five million."

"Only!" I exclaimed. "Five million is something, after all."

"Oh, it's nothing," he said. "I'm going to give a million to Diego." He took a hundred thousand for himself, then went to give the million to Diego, came back, wrapped the money again in the tissue paper, leaned down and with a large, nonchalant gesture tossed the package under the bed.

I laughed very loud. "You're some clown," I said. "And what a ham!"

Alberto laughed with evident glee. "Yes," he admitted, "that was a little affected. But it was funny, and it didn't do harm to anyone."

Then we discussed at some length whether, in fact, the money was best hidden under the bed or under a pile of rags on the other side of the studio. "I have seven million hidden in my bedroom," Alberto added.

"Then why did you have to have five million more?" I asked.

"Because that seven million is so well hidden that I can't get at it," he explained.

Taking the money out from under the bed, we

tried hiding it in several different places before our game was suddenly interrupted by a knock on the door.

It was a woman poet who had been pursuing Alberto in the hope of obtaining an etching of his to accompany one of her poems in a forthcoming volume. She had a rather pretentious turn of phrase and referred to the portrait as "inspired." Giacometti visibly found this adjective most inappropriate, though he was too polite to say so. I left shortly.

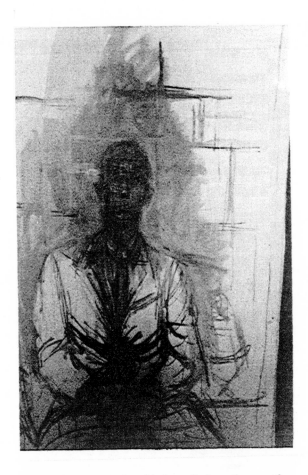

September was in its third week, but the weather was mid-July. Sometimes I went swimming in the mornings, after which I'd lunch outside and then go to the studio. The afternoons were clear and pale blue, perfect Île-de-France afternoons, but the exhilaration of the weather more often than not died in the gray studio, which has always seemed indifferent to such minor eventualities.

When Giacometti isn't at the studio, he usually leaves a note on the door saying where he is. It

usually says, "Suis au café-tabac, rue Didot." And that was where I found him the afternoon of September 22. He was seated in the back at the table he habitually occupies, his head in his hands, looking glum.

"You don't look very cheerful," I said, sitting down.

He didn't answer. Then I told him about having been to the Opéra the day before to see Chagall's new ceiling. That interested him. He was very curious to see it himself, and had an invitation to the gala opening the next day.

"Let's go and work," I suggested. He agreed, so I stood up and walked outside. But he didn't follow. Looking back, I could see him still sitting inside, his head in his hands, staring at nothing.

Finally, though, after I had waited about five minutes, he did come out. He looked down the rue d'Alésia, where the leaves of the acacia trees were fluttering in the sun. "It's beautiful," he said, nodding. Then he murmured, "One should be a tree." For another five minutes, at least, we stood there, while he gazed down the long vista of trees, nodding his head slightly, seeming physically to absorb the scene. Then we crossed the street. "I'd like to do some landscapes," he said. "But I can't do everything. Besides, it's impossible to do landscapes in Paris, because people gather round to watch you, and I find that intolerable. Of course, I could do them at five in the morning. But I'm always too tired by that time."

In the studio, everything was just as we had left it the previous afternoon, since he hadn't worked with Caroline the night before, having had dinner with his dealer, Pierre Matisse.

As soon as we had started to work, he said, "It seems impossible. How can you hope to do a nose | 58

in relief on a flat canvas? It's an abominable undertaking."

I didn't say anything. I simply sat there in what I had come to think of as a state of active passivity. Through the large studio window I could see the sun in the treetops above the low roof line on the other side of the passageway. Inside the studio there was Giacometti directly in front of me, with the canvas just to the left of him, between me and the door. Behind him and below the window stood a large table covered with empty turpentine bottles, heaps of papers, dried paint tubes, discarded brushes, and plaster casts of small sculptures. To the right were several sculpture stands holding works in progress. In the corner stood a number of tall plaster figures, and on the wall behind them a large black head had long ago been painted.

Presently he remarked, "It's not necessary to paint a ceiling for the Opéra to realize how difficult painting is. Besides, that's house painting compared to what I'm trying to do. It isn't desirable to do large things, either in painting or in sculpture."

"But you've done some quite large things yourself in your time," I observed. "How about the pieces that were supposedly for the Chase Bank?" These were three tall standing women, each more than six feet high, a large walking man, and a monumental head of Diego, all executed in 1960 in view of a project for the plaza of the Chase Manhattan Bank in New York. This project was later abandoned by Giacometti.

"Oh, those were merely decorative pieces," Alberto said. "They didn't mean much. I did them very quickly."

"As a matter of fact," I said, "you worked on

them for an entire winter. I remember it very well. The crust of plaster on the studio floor was so thick it took Annette and me a whole afternoon to clean it up. Do you remember?"

"Yes," said Alberto. "But if I worked on those pieces as long as that, it was simply because I kept changing them all the time out of curiosity to see how they'd look, not because I had any real problems with them."

"There's the *Man Pointing*. That's a big piece."

"Yes. It's the maximum size. I did that piece in one night between midnight and nine the next morning. That is, I'd already done it, but I demolished it and did it all over again because the men from the foundry were coming to take it away. And when they got here, the plaster was still wet."

He worked for a time, then said, "Everything has to come through the drawing. After that, the colors will be inevitable. In two days I'll know whether there's any possibility of going on."

Annette came in. We talked, joked, but he kept on working. "I'm in fighting form," he said. "I'm in real fighting form, because I didn't work last night."

The sitting lasted for more than an hour and three quarters without a rest. When we stopped, the picture looked very strong, starkly delineated, though of course only the head had changed. But I no longer watched the day-to-day variations as closely as I had at first. Now I felt almost physically helpless, in the grip, as it were, of the painting's interminable transformations.

After we started to work once more, he said, "I have to destroy everything again. There's nothing else to be done." His mood began to grow somber. "Anyway," he said, "it's impossible really to accomplish anything. I'll just have to acknowl-

edge that I'm not a painter, that's all." He sighed and let his head hang.

"Oh, Alberto!" exclaimed Annette, protesting gently. "Don't be like that."

"Drawing is the basis of everything," he said. "But the Byzantines were the only ones who knew how to draw. And then Cézanne. That's all."

Apparently the work was going from bad to worse. "It's abominable," he moaned. "It's unbearable. I'll die of it!" He stood up and stepped back to look at the picture from a distance, which he had never done before during a sitting. "Merde!" he cried. "The head is still lopsided. What am I going to do?" He let out a loud, hoarse scream.

"Oh, Alberto!" protested Annette again.

"Maybe we'd better stop for today," I suggested, "since it's not going so well."

"No, no," he insisted. And for a time he kept on working. But finally in a tone of complete despair he said, "We might as well stop. Stand up. It's no use. I'll accomplish more tomorrow in five minutes than now in half an hour."

I stood up, while he took the painting off the easel and put it on the floor under the light. The head certainly was askew. "It's hopeless," he muttered. "At that distance it's hopeless. How can I make a nose really perpendicular in relation to the body? The simple fact is that I don't know how to do anything. People think I'm affected when I say that, but it's simply the truth."

I tried to cheer him up by saying that progress had nevertheless been made on the picture as a whole. But it was no use.

"Shall I give up?" he sighed. "Maybe I should give up."

"No, no," I said.

"Well, maybe not. We'll see what happens to-morrow."

I went out into the passageway and back to Diego's studio. "It's not going very well," I told him.

"Tomorrow it will go better," he replied dis-passionately.

We talked of other things. Suddenly I heard Alberto shouting, "Lord! Lord!" I went back down the passageway to his studio. "Let's work a little longer," he said. "I can't leave it like that."

"All right," I said, sitting down. "But it will be dark soon."

"Is this beginning to get on your nerves?" he asked.

"No," I said.

"You must hate me."

"That's absurd. Why should I?"

. "Because I force you to go through all this."

"Don't be crazy," I said.

And yet, inasmuch as it was then expressed in the particular acts of painting and posing, there were elements of the sadomasochistic in our rela-tionship. At moments it seemed difficult to deter-mine which one of us was responsible for the aura of anxiety that surrounded our mutual work in progress. I as the model, though a fortuitous ele-ment, was nevertheless one without which the work could not proceed. Consequently, it was sometimes easy to confuse my appearance with my person as a source of his dismay. On the other hand, if he could not work without me, the paint-ing could not exist without him. He had absolute control over it, and by extension—taking into ac-count its nature, my admiration for him, my de-sire to possess the finished product, and the fact that I was remaining in Paris only to pose—control over me, too. The painting seemed at

times to exist both physically and imaginatively between us as a bond and a barrier at once. However, in a situation of which the ramifications were inevitably complex, not to say ambiguous, it would have been difficult to determine exactly what acts were sadistic and/or masochistic on whose side and why.

He worked for a few minutes, using the large brush. "I have to obliterate everything," he said. "Then tomorrow I can start out in the right direction. It may not look like progress, but it is."

"Besides," I said, "it's better to work a little more if for no other reason than not to stop with such a terrible impression."

"That's true," he said. "Everything's disappearing now. I must be crazy even to try to do what I'm trying to do. Nobody else is painting frontal portraits like this."

"Haven't you ever done profiles?" I asked.

"Yes. One or two. But a profile isn't half as difficult. The center of it is the ear, and ears don't interest me. When you look at a person, or think of how he looks, it's always full face."

Before long, some people arrived to talk to him and we had to stop. I turned on the lights. The portrait looked better. The head had come back more or less into line with the body, but it was gray and vague, it looked very far away and not at all like me, if that were any criterion.

"Tomorrow," he said, "it will go better. We were right to work a little longer."

While he received his visitors, I went into the bedroom next door to talk to Annette. I felt utterly exhausted. The physical delight of the beautiful afternoon now seemed not only remote but almost inconceivable.

"How much longer do you think it can go on like this?" I asked.

| 63

Annette laughed and shrugged. "There's no telling," she said. "It could go on and on indefinitely. Alberto seems to find it more and more difficult to finish things."

"But I can't stay here forever," I said. "I have to get back to New York. I've already postponed my departure several times. What shall I do?"

"I can't tell you. But I suppose you should talk it over with Alberto and fix a deadline. He likes to work against a deadline sometimes. And then maybe at the last minute you could extend it a day or two. That had fairly good results with Yanaihara once when he was going back to Japan, though he didn't do it deliberately. The portrait turned out very well."

"I don't know what to do," I said. "But I'll have to decide soon. Anyway, I can't go on like this. If only the portrait seemed to make some real progress each day, it would be different. I know Alberto has to do it in his own way, but sometimes it seems that you've posed for hours and hours and that nothing has happened at all. In fact, sometimes it seems to go backwards."

"If you'd posed as much as I have," Annette observed, smiling, "that wouldn't bother you. But I don't want to pose any more the way I used to, because your whole life can simply be swallowed up by it."

"I'll talk to him about leaving," I said. "We'll see."

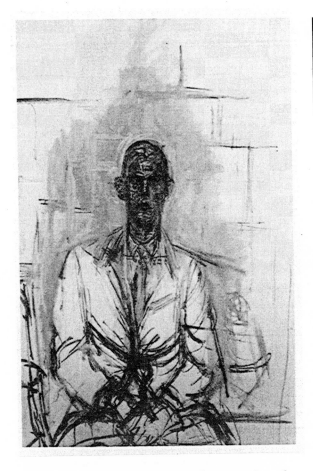

When I arrived at the studio the next day, the door stood open but Alberto was not there and Diego had no idea where he was. I set out for the café. It was another exceptionally beautiful day. I felt quite elated and thought that if I found Alberto depressed I'd surely be able to cheer him up.

He was sitting in his usual place at the back of the café. He exuded gloom. As soon as I sat down at the table my elation began to dwindle. I re-

alized that the force of his personality is far too great to be affected by someone else's delight in a lovely afternoon. He said, "I'm so nervous I could explode!" He kept rubbing his hands together. "Don't you feel cold?" he asked.

"No, not at all," I said. "It's a beautiful day."

But he insisted that it was very cold and that he would have to turn on the electric heater in the studio. Suddenly he made several hideous grimaces and held his face in his hands. Then he said quietly, "You see what a miserable creature I am?"

"Yes," I said. "I see." And, indeed, miserable was what he did seem to be. This, I thought, was the true Giacometti, sitting alone at the back of a café, oblivious to the admiration and recognition of the world, staring into a void from which no solace could come, tormented by the hopeless dichotomy of his ideal yet condemned by that very hopelessness to struggle as long as he lived to try to overcome it. And what consolation was it that the newspapers of many countries spoke of him, that museums everywhere exhibited his works, that people he would never know knew and admired him? None. None at all.

Presently we walked back to the studio. He plugged in the electric heater. Since to me it was already quite warm, I decided to take off my undershirt and began to do so.

"What are you doing?" he asked.

"I thought it might be more amusing if I were to pose in the nude for a change."

He was not amused. "Your head is work enough," he grumbled, "without bothering about your body."

When he sat down to start work, he murmured, "I'll never find a way out." And a little later,

nodding toward the canvas, he said, "Hell is right there."

"Where?" I asked. "On the tip of my nose?"

"No. It's your whole face."

I laughed, but he didn't.

"This ought to be forbidden," he said after a time, "as it is among the Jews."

He was referring, I realized, to the fact that they discountenance the representation of the human figure, and I said, "But maybe that makes painting more difficult."

"No," he said. "The most difficult thing to do well is what's most familiar."

At one moment, while he was working, his cigarette slipped from his fingers. He moaned, he whined, he almost sobbed. Then he picked it up. "I'm becoming senile," he said with a sigh.

"Not at all," I protested, though I knew he realized perfectly well I didn't take him seriously. And yet at times I wondered to what extent he himself might take seriously remarks which even as he made them were intended to suggest a state of mind that was very different and far more complex.

"Don't say no out of charity," he said. "It's nice of you, though, you and everybody else. Besides, you probably say to yourself, 'It doesn't matter, since he's going to croak soon anyway.'"

"Don't talk nonsense," I said.

"I'm not. I won't be able to go on much longer like this."

"I don't want to listen to that kind of talk," I said.

Then we remained silent for some time. He worked steadily, while I watched his movements and concentrated on trying to remain motionless.

"It's impossible to do what I'm trying to do,"

he said after a while. "No one else could do it. Moreover, no one else is even trying to do it."

Before long, he said that he would have to rest for a few minutes. He took the canvas from the easel to study it. "It's coming along," he said. "It's reached a point now where in five minutes it could go very far."

The head was narrower and longer than the day before, with more precisely defined features. But it was still a little lopsided.

He complained of feeling tired and cold. He had had an attack of the flu just before going to London, so I suggested that he lie down and rest for a little while. After an hour I went into his bedroom. He was in bed with all his clothes on, reading *The Spy Who Came in from the Cold*. In bed he felt fine, he said, but he wasn't sure he would feel like working again that day. I waited another half an hour, talking with Diego, then went back to the bedroom. Alberto was enjoying *The Spy* but feared he might have a fever. However, he didn't want to take his temperature, because he had promised to go with Annette that evening to the gala soirée at the Opéra for the inauguration of Chagall's new ceiling. If he had a fever, he wouldn't be able to go, which would disappoint her. I insisted he take his temperature all the same. It was exactly 100°. "No Opéra," I said.

"Annette will be disappointed," he said. "I'll have to call her."

When he had done that, he undressed and got into bed. "The portrait is coming along," he said. "I'm not giving up."

"Of course not," I said.

He mentioned that his dealer was coming to the studio soon and that it would be necessary to make a selection of bronzes, paintings, and draw-

ings for him. Giacometti was particularly concerned about what Pierre would think of the bronzes that had been cast. He said, "I only had them cast to see what they would look like. In bronze a thing looks so different. It helps me in my work to be able to see things differently."

"Of course," I said.

"You talk to me as though I were senile," he protested irritably.

"Not at all," I said. "You don't expect me to disagree with you just to prove that I'm paying attention, do you?"

"No, no," he murmured. "But I'm angry to be sick. It's so stupid."

After a time he became more cheerful, laughed and recited some bawdy poems that he knows by heart. I telephoned the doctor, who promised to come to the studio later. Annette soon arrived. She was less disappointed not to go to the Opéra than concerned about Alberto. As I prepared to leave he said, "Be sure to come around tomorrow anyway. Maybe we can work. This is forced labor."

"We'll see," I said.

In the morning I learned from Pierre Matisse that Giacometti was better, that the fever had gone, but that probably he wouldn't feel much like working that afternoon. However, as I had promised, I went to the studio about four o'clock.

He was in bed, still reading *The Spy Who Came in from the Cold*. He felt fine, he said, and found staying in bed and not working so enjoyable that he was tempted never to get up again. I stayed for a couple of hours. We didn't mention the portrait at all. But as I was leaving he said that we would certainly work the following day.

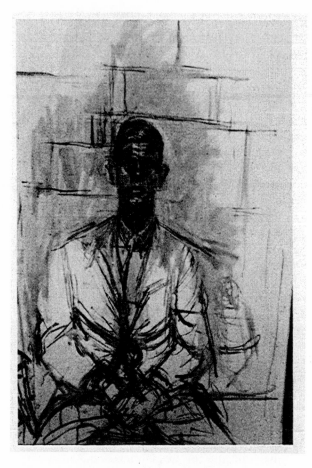

When I arrived at about three in the afternoon, he
was asleep. It was my knock on the bedroom door
that wakened him. He looked very rested, extra-
ordinarily young, boyish even. I remarked on
that. He laughed and said that he felt very well.

We went into the studio, where for a time he
worked on the bust from memory of Diego. It had
gradually come to replace the tall figure as his
principal sculptural preoccupation.

Giacometti has a habit not only of drawing on

the newspapers or magazines which he always carries with him but also of scribbling on them notes to himself which are reminders of what concerns him most at the moment and of what he must not, and indeed cannot, forget. For instance, on the front page of *France-Soir* for Thursday, September 24, he wrote in Italian, "Everything fine if . . ." And then in a box were listed the names Lord, Caroline, Diego, Annette. They were his models of the moment, though Annette's portrait in progress had not then been worked on for some weeks.

"I finished that book," he said as he sat down to begin work on the painting. For some time he talked about *The Spy*, analyzing the plot and pointing out what seemed to him to have been its contradictory and illogical details. All these arose from the natures and personalities of the characters, not from the situation. Anecdotes are less interesting by far to him than human nature, of which he is a lucid and dispassionate judge.

It wasn't long before he announced that the picture was going very badly. "Things look black, my poor friend," he murmured. And he went on to say, as so often before, that the entire enterprise was abominable, impossible, absurd, doomed. He wanted to paint still lifes, he said, only still lifes. But a moment later he added, "They would be just as difficult as portraits."

He was working on the head, doing it over and over and over, painting a few strokes, looking at me, painting a few more strokes, looking at me again, puffing on a cigarette from time to time, murmuring exclamations of disgust and despair. I sat there, immobile, silent, perspiring, staring him in the eye as he occasionally said, "Hey, look here!" or "Don't move!" or "Show me!" And at moments it seemed that the situation had become

utterly unreal. The portrait qua portrait no longer had any meaning. Even as a painting it didn't seem to mean much. What meant something, what alone existed with a life of its own was his indefatigable, interminable struggle via the act of painting to express in visual terms a perception of reality that had happened to coincide momentarily with my head. To achieve this was of course impossible, because what is essentially abstract can never be made concrete without altering its essence. But he was committed, he was, in fact, condemned to the attempt, which at times seemed rather like the task of Sisyphus. And I was temporarily involved in that attempt. But sometimes I forgot the temporary nature of my involvement. And then what was happening to us both through and because of the painting became unreal, yet more than real in a way, since at the very root of the situation lay the nature of reality itself. Thus our presence and our relationship occasionally seemed to proceed from, and to partake of, the absurd, to be at once both ridiculous and sublime.

A young man came to the door and asked Giacometti to autograph a book, which he did very amiably.

He worked on for a time, then said, "There's still the entire body to be done. But as soon as I have the neck in place the rest will come of itself. By tomorrow evening I'll have it. One must strike out boldly."

Later it appeared that the work was again going less well. "I don't know how to do anything at all," he said. "If only Cézanne were here, he would set everything right with two brush strokes."

"I'm not so sure about that," I said. "After all, Cézanne had plenty of trouble painting, too. He was always complaining bitterly about it."

"True," he murmured. "Even he had trouble."

The light in the studio gradually began to fade. But he worked on. It seemed to me that we'd been alone there forever, like prehistoric insects caught in the jewel glue of some extinct conifer. "I've got you," he said. "You can't escape me now." I wondered exactly what he meant. But it didn't matter. Whatever he meant, it was true.

At last it had become so dark that we had to stop. When he took the painting off the easel and put it under the light at the back of the studio, he seemed almost surprised. "Now we're getting somewhere," he said. He was evidently very pleased. "You see? The space around the head has become much more precise. And the relation of the body to the head is stronger, because the head itself is stronger. It's not lopsided any more." He touched the painting in several places with his fingertip, modifying a line here, a shadow there, and I remembered that Titian is said to have finished his pictures more with his fingers than with his brushes. For once Giacometti seemed almost satisfied. But not altogether. "To-morrow," he said, "it will go even better."

"Yes," I said. "And that reminds me that we have something to talk over."

"What?"

"When am I going to leave?"

"Whenever you want to."

"Yes. But there's the painting to think of."

"It mustn't interfere with *your* life," he said.

"No. But now that we've gone so far it seems too bad not to go further. I don't mean you should finish it. I know there's no question of that. But I'm sure you could go further, and I don't want to prevent that by going away."

"One can always go further. You'll have to leave when you have to, that's all." | 73

"Shall we say next week then? Today is Friday. Shall we say next Wednesday? That gives us four more sittings of three or four hours each. In four sittings we should be able to go far."

He nodded. "One *should* be able to go far in one sitting. Next Wednesday is all right then."

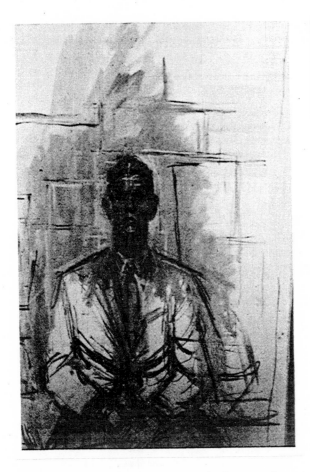

Annette and Alberto were in the bedroom, where they had just finished eating lunch—a very unusual event, and due only to Alberto's recent fever—when I arrived the next day. He was sitting on the bed, studying the color reproductions in two large art books, one of paintings by Jan van Eyck, the other of Byzantine mosaics. On the blank page opposite van Eyck's *Man in a Red Turban* he had made a detailed copy with his blue ballpoint pen. After a few minutes he closed the

books with a bang and suggested that the three of us go to the café for some coffee before he and I started to work.

In the street as we walked along he suddenly started to sing in a loud, raucous voice. Coming from the opposite direction were two prim, bourgeois ladies with flowered hats. They stared at him in amazement and, after we had passed, turned round to gaze after us with expressions of incredulity and indignation. They themselves appeared to me such caricatures of what they obviously were that I shouted with laughter. Annette and Alberto were also highly amused. And in the rue d'Alésia, after we had turned the corner, Alberto began to sing again. I again laughed. "Between your laughing and my singing," he said, "we're liable to be arrested for disturbing the peace." Then we walked on a little way and he said, "Everything looks different today. Everything is more beautiful." In front of the café he stopped to gaze at the trees. "I've never seen them like that before," he murmured. Inside the café, when we were seated at the table, he said, "I've never seen the trees like that before."

Annette stayed with us only a short time, drank her coffee, then went off to do some errands. After she had gone he began to draw on the fly leaf of a book he'd had in his pocket. It was a view of the café and it took shape quickly with nervous, incisive strokes of his ball-point pen, which he hardly raised from the page as he drew, glancing up constantly at the scene before him. When he had finished, I said, "It's difficult for me to imagine how things must appear to you."

"That's exactly what I'm trying to do," he said, "to show how things appear to me."

"But what," I asked, "is the relation between your vision, the way things appear to you, and the

technique that you have at your disposal to translate that vision into something which is visible to others?"

"That's the whole drama," he said. "I don't have such a technique."

"I understand what you mean," I said. "That's relative to what you consider the absolute. But you *do* have a technique, after all."

"So little. When I was a young man, I thought I could do anything. And that feeling lasted until I was about seventeen or eighteen. Then I suddenly realized that I could do nothing, and I wondered why. I wanted to work to find out why. That is what's kept me working ever since, moreover, that desire to find out why I can't simply reproduce what I see. I started out with the technique that was available at hand, which was more or less the impressionist technique, and I worked with it until about 1925. Then suddenly, while I was trying to paint my mother from life, I found that it was impossible. So I had to start all over again from scratch, searching. And it seemed to me that I'd made some progress, a little progress, till I began to work with Yanaihara. That was about 1956. Since then, things have been going from bad to worse." He sighed, glanced at the drawing he'd just done, and closed the book.

We went back to the studio and at once started to work. "Four more sittings," he said. "That's plenty of time to open the door or to close it for good. In any case, the picture will be yours. If it's bad, I'll give it to you with indifference. If it's good, I'll give it to you with pleasure."

"Thank you," I said. "I mean, I don't know how to thank you."

"It's unnecessary. We've worked on it together, and I'd rather you had it than a stranger."

"Well, it's true that I feel my participation has

been an active one in some way. I haven't felt that I was just an apple, like Madame Cézanne."

"Of course not. The model is very important. Yanaihara and Caroline feel the same way you do about it, that posing is an active participation in the work. It's not easy, either. I know that. But Genet felt that posing was completely passive. And he stopped posing because he felt that he was being transformed into an object. I thought that that was a very literary attitude."

As the work progressed, he became discouraged. I can't remember now, and I didn't notice at the time, whether his moments of relative satisfaction and of discouragement came and went in some cyclical pattern. They may have. In any case, as time passed I came to wonder whether the appearance of the painting might not be at its best—from an objective point of view, of course, not from his own—just when he felt that things were going most badly.

He shook his head, gasped, swore. "Excuse my bad language," he said, meaning, I thought, to suggest that, despite all difficulties, his sense of humor survived.

"It's impossible!" he exclaimed. "It's simply impossible at this distance. But it's an illusion to think it would be any easier farther away. When van Eyck painted the *Man in a Red Turban*, he was certainly farther away than this."

"Do you really think so?" I asked. "That painting is so detailed you'd think he must have been very close to the model."

"No. One can see details better at a distance. Color, too. It's an illusion to think you have to be close. Anyway, van Eyck isn't as good as I thought he was. The Byzantines are infinitely superior."

He continued working, using the large brush. "What I'm doing is negative work," he said. "You have to do something by undoing it. Everything is disappearing once more. You have to dare to give the final brush stroke that makes everything disappear."

"That's a daring you don't lack," I remarked.

"It's not as easy as you may think," he answered. "Sometimes it's very tempting to be satisfied with what's easy, particularly if people tell you it's good."

Later he said, "What's essential is to work without any preconception whatever, without knowing in advance what the picture is going to look like. Van Gogh, for instance, worked with a preconception. He used to write to Théo, describing pictures he hadn't yet painted. Picasso always has a preconception. But not Corot. His figure paintings are absolutely superb. And the *Belfry of Douai*, in the Louvre, it's like a dream. It is very, very important to avoid all preconception, to try to see only what exists. Cézanne discovered that it's impossible to copy nature. You can't do it. But one must try all the same, try—like Cézanne —to translate one's sensation."

After working in silence for a while, he began to moan and swear again. "It's abominable," he said. "It's hopeless."

By then I was becoming accustomed to such exclamations, though I certainly did not imagine his anguish to be any the less intense simply because I'd grown used to it. However, I was able at the same time to think of other things. And I happened just then to be remembering the ladies in the street who had looked so astonished at his singing. I laughed.

"Do you think this is funny?" he demanded. | 79

When I explained why I'd been laughing, he said, "I'd have made a better clown than painter. It would have been easier and funnier."

Soon we stopped for a rest. I went into the telephone room to make notes. When I returned from this clandestine activity, Alberto immediately stopped working on the bust of Diego and we began again with the painting.

"Merde!" he cried. "You don't look at all the way you did before."

"But I am," I said.

"I don't see it," he insisted. "Now what am I going to do?" But he worked on resolutely. After a little while he said, "I'm destroying everything with great bravery." And, indeed, from the way he appeared to be painting I inferred that he was.

As long as things seemed to be going so badly anyway, I thought I might try to take advantage of the moment to procure a minor satisfaction. From the very beginning I had been bothered by the presence in the painting of the tall stool that he had sketched in at the left during the first sitting. I'd mentioned this once or twice. Now, seeing that he was once more using the large brush, I mentioned it again. He said, "All right, I'll take out the stool to please you." And he gave a few strokes of his brush across that area of the canvas. The stool did not disappear completely, but it became less important. It was not touched again.

Darkness gathered little by little in the studio. At last I could barely make out the features of his face. He said, "I like working in the dark." Finally, though, he did have to stop.

He was not pleased with that day's work. The shadow beneath the chin was too dark, the highlights on the forehead too light, and the space around the head was interlaced with gray lines which made it appear that my head was inside a

small cage. "But all this is necessary for tomorrow," he insisted.

"There's been some progress, though," I said, "hasn't there?"

"Oh yes. There is always some progress, even when things are at their worst, because then you don't have to do over again all the negative things you've already done."

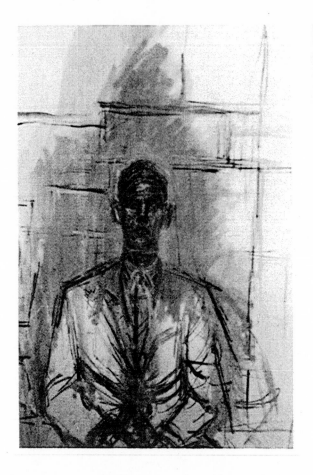

When I arrived the following day, Giacometti was discussing business with Pierre Matisse. It was almost five before he left. But even then Alberto was in no hurry to begin work on the painting. Instead, he started modeling the bust of Diego. To get him to the easel, after I had put everything in place, I had to pull on the sleeve of his jacket.

"I'm very tired today," he said. "I was up till five, and then I didn't sleep very well."

Once having started to work, he soon said,

"I've got to destroy everything again."

"That was to be foreseen," I said.

"Not to this extent," he said. "Look at me! Merde! I'm right back where I was in 1925. It's absolutely impossible to reproduce on a canvas what I see."

"Of course," I said. "Which simply brings us back again to the fact that one cannot hope to copy nature."

"But that's the only thing worth doing," he said. "It's the only thing I'm interested in."

He told me a little later that he had gone over all the drawings in his portfolios and that Pierre was going to take fifty-eight of them. But he had not given him, he said, a drawing of me that he had done just before going to London, because he thought that maybe I'd want it.

"Well," I said, "of course I'd like to have it, but I can't take everything. Maybe, too, you'd like to keep it for yourself."

"I couldn't care less!" he said. Then he added, "Between now and Wednesday evening we'll see. If the painting turns out well, you'll take the painting and the drawing. If it doesn't turn out well, you'll get nothing. Because it's Thursday that you're leaving, isn't it?"

I didn't reply, since I realized perfectly well that he knew it was Wednesday.

Smiling mischievously, he said, "It *is* Thursday you're leaving, isn't it?"

"You're not supposed to make the model laugh," I said.

Then we both laughed.

Presently there was a knock at the door, and he went to open it. Outside was a woman who asked in a very pronounced American accent whether a painter named Haydon lived nearby. He said he didn't know. Then the woman, having

observed the name on the studio door, asked whether he happened to be *the* Giacometti. He replied that he was, and she went on to say how much she admired his work, which she had seen in various American museums. He thanked her. When he had returned to his easel and started work again, I said, "*The* Giacometti! So you do know who you are! You know that you're famous and that people admire your work."

He smiled. "I'm always surprised when I realize that strangers have heard of me."

"It's not at all surprising. After all, your name is often in the newspapers."

"Oh, not so often."

"Yes, it is."

"Not as often as General de Gaulle's!" he said, smiling.

"But how do you feel about having become so famous and having achieved so much?" I asked.

"I feel different things at different times. I resisted the intrusion of success and recognition as long as I could. But maybe the best way to obtain success is to run away from it. Anyway, since the Biennale* it's been much harder to resist. I've refused a lot of exhibitions, but one can't go on refusing forever. That wouldn't make any sense."

"But doesn't all this force you to realize that you *have* achieved something no matter what you may think when the work is going badly?" I asked.

He shook his head. "When I was a boy, I felt that I could devour the world and accomplish anything. That was when I was fourteen. But little by little I realized that that was absurd. By the time I was twenty-five I no longer expected to achieve anything stupendous. And how right I

* Giacometti was awarded the prize for sculpture at the Venice Biennale Exhibition in 1962.

| 84

was! Yet in the surrealist group I did have some reputation as an avant-garde sculptor. Of the work of all those years I can say only that I did it because it was so easy. The sculptures used to come to me complete in my mind. Then the only problem was executing them and that was a mechanical matter, no more than that, with which Diego helped me. But I was expelled from the surrealist group because I wanted to work from a live model. That was a relief. I hated the feeling of competition, of one artist working against another and even exploiting ideas that were sometimes not originally his own. I was happy when I started to work in complete isolation. I even regret those years now, because then I was able to work for months and months on the same thing without interruption. Now it's no longer possible. There are too many outside demands. During those early years I earned my living by making objects, lamps, vases, and such things, for the decorator, Jean-Michel Frank. Other artists did the same thing, and most of them seemed to think it was shameful in some way. But I never felt that. I devoted as much care to making a lamp as I did to making a sculpture, because I felt that if I could make a lamp that was a really good lamp, that would help me with everything else. And it did. By making those objects, I realized the limitations of some of my earlier work."

"Maybe," I said, "that's why your lamps are true objects of art rather than merely lamps."

"Maybe."

"Have you ever made a sculpture that was really abstract?"

"Never, with the exception of the big cube I did in 1934, and in fact I considered that one as a head. So I've never done anything that was really abstract."

Later I asked, "Do you ever think of your youth with nostalgia?"

"No," he replied. "It's impossible, because my youth is now. Sometimes I used to think of it, but now I never do except when I'm talking about it. I should say that now is my childhood, because I'm just learning how to do what I want to do."

The work was apparently not going well, however. He was once more painting out, or over, the head. I remarked that I would be very curious on Tuesday to see whether he stopped work at a particular moment, when he might presumably feel that the painting was at its "best," or whether he would work till the very last minute of daylight.

"I'll work till the very last minute," he said. "Or no. Maybe not. We'll see."

The light of that day had already begun to fade in the studio. He observed that during the past two weeks it had begun to get dark perceptibly earlier. I said that I liked the long nights. "So do I," he agreed. "But I like the short ones even more. I love going to bed when it's already daylight, and I almost always do, except in the middle of the winter. I like hearing the birds wake up in the morning. There are blackbirds in the trees here near the studio. They must always have been there, but it's only in the past two years that I've heard them. That's strange, isn't it? And it's only in the past two years that I've come to enjoy the noises of automobiles, too."

"Do you even enjoy the noises of the cars and trucks that pass right under your bedroom window at Stampa?"

"I adore it."

Before long, it was almost dark. I said, "You can't possibly see anything now."

"Yes, I can," he insisted. "It's very good to

work in the last light, because then you can see clearly the things that catch the light most."

At last, however, he stopped. I turned on the lights and we studied the picture, examining it almost as though it were an object that we had just discovered and were anxious to identify. The cage-like effect around the head had disappeared, but the face itself appeared to me more blurred and vague than the day before. Yet the total effect seemed nevertheless to be one of positive change. He was pleased.

"There's an opening for tomorrow," he said.

A visitor arrived then, and I left.

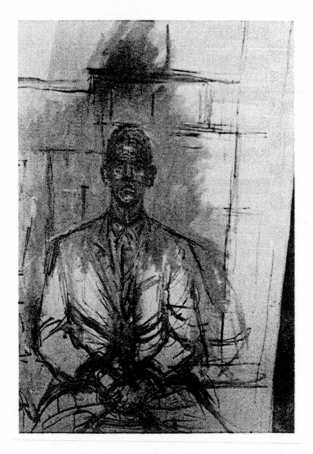

The work went badly almost from the outset the following afternoon. He announced that he was making everything disappear. "I have to make a little hole in nature," he declared.

"And pass through it," I said.

"Yes. I've made a little hole, but it's too small to pass through."

Then, after working for a time in silence, he said, "It's curious. Everything is shrinking. It looks big enough, but there's no more place for everything."

And a little later he said, "If someone else tried to do what I'm doing, he'd have the same difficulties I'm having."

"But," I asked, "is anyone else trying to do what you're trying to do?"

"I can't think of anyone. And yet it seems simple. What I'm trying to do is just to reproduce on canvas or in clay what I see."

"Sure. But the point is that you see things in a different way from others, because you see them exactly as they appear to you and not at all as others have already seen them."

"It's true that people see things very much in terms of what others have seen," he said. "It's simply a question of the originality of a person's vision, which is to see, for example, and *really* to see, a landscape instead of seeing a Pissarro. That's not as easy as it sounds, either."

The work continued to go badly. He said, "It's more difficult than the first day. We'll have to rest a little." He took the painting off the easel and stood it at the back of the studio.

It had never looked so well. The head was no longer at all lopsided and the features were vividly delineated and realized in relation to each other. Moreover, it wasn't a bad likeness. I was delighted and said so.

"There's an opening," he said. Then he went off to make some telephone calls.

As soon as he came back ten minutes later, we began work again. He said, "I'm demolishing everything."

"What a dirty trick!" I exclaimed.

He laughed. "You should talk! Just when everything's beginning to go well, you leave. And why? For no good reason."

"The reason is good enough for me," I said. "I have my life in New York."

Alberto smiled almost sheepishly. "I was only joking. You mustn't take me seriously."

Before long, he said that he was tired and hungry and wanted to go to the café for something to eat. I stood up and went behind him to look at the painting.

"Are you disappointed?" he asked.

"Not at all," I said. And I wasn't. Though not, perhaps, as intense and fully developed as half an hour before, the picture, both as a painting and as a portrait, still appeared to me at its best. I felt elated. The next day was to be the last sitting and although I knew that the picture could change radically for better or for worse in a short time, this seemed very promising. I had never expected that he would in any conventional sense "finish" the portrait. My only concern was that on his own terms he should leave it, or "abandon" it, as Cézanne would have said, in a condition that would represent as nearly as possible the fullest realization of its innumerable metamorphoses. Gone now was any trace of the depression I had at times experienced, of the feeling that I was in my own way as bereft of hope as he in his, and that the portrait had somehow become for me as well as for him the rock of Sisyphus.

On the way to the café he said, "The painting looks flat. It ought to be in depth."

"But it *is* in depth," I protested.

"Not enough!" he exclaimed. Then, as we went along the rue d'Alésia, he looked up at the sky, which was bright, and said, "I've never seen the sky that way before. It's so high." He went to buy the newspapers while I waited inside the café, and when he came back he said, "The painting is flat. One must do something which is like a relief on the canvas, even behind the canvas. It isn't enough that it should *seem* to be in relief."

"But it can't really be in relief," I objected.

"No. And yet it must be."

So once more we were confronted by the utter impossibility of what Giacometti is attempting to do. A semblance, an illusion is, in any case, obviously all that can be attained, and he knows it. But an illusion is not enough. This inadequacy becomes literally day by day, I think, less acceptable, less tolerable—almost in a physical sense—even as he strives to go on, to go further. There is always, perhaps, a possibility of going a little further, not very far but a little further, and in the realm of the absolute a little is limitless. It is this possibility, I think, that gives to Giacometti's work such arresting intensity, an intensity that has increased with time. But it may also be that it is just this possibility which has made it more and more difficult for him to produce work that seems conventionally "finished." This is apparent more in the paintings than in the sculptures, for a sculpture by its three-dimensional existence inevitably compels acceptance more immediately than does a two-dimensional painting, which is obliged to make a correspondingly greater concession to the conventions of illusion. And one of the most rigidly established of these conventions has been that a representational image, however remote from actual reality, must nevertheless in its own terms appear complete and homogeneous. Like so many other visual habits, however, and like so many conventions, this attitude constitutes a limitation. What is important is the acuity of the artist's vision and the degree of realization of that vision, nothing more. And Giacometti's visual acuity has not, I believe, been equaled since Cézanne's. His ability to realize that vision is by definition unique, but it is also uniquely his own and has attained a degree of objective accomplishment in keeping

with the comparison to Cézanne. Moreover, this realization sometimes unquestionably depends for its fullest effect upon the unfinished appearance of an individual work. It was obvious even as long ago as Michelangelo that the *non finito* quality of certain works of art may be an integral part of the imaginative effect deliberately conceived and consummated by the artist.

On the way back to the studio Giacometti complained of being tired. "It's exhausting," he said, "this necessity for total concentration. The whole thing seems to hang by a thread. You're always in danger."

As that moment seemed an appropriate one, I tried to tell him what a wonderful experience it had been for me to pose for him and how much I appreciated it.

"Are you out of your mind?" he said.

That was the end of that. I realized that he could not logically accept the idea that it might be something like an inspiration for someone else to participate in his struggling and—to him—foredoomed effort to reach the inaccessible.

When we were back at the studio, Alberto asked Diego to look at the painting. His brother's opinion is very important to Alberto, and understandably so, for Diego is a lucid, severe critic, who has no patience with superficial effects and never hesitates to say what he thinks.

"It's coming along," he said. "It's just beginning to have real possibilities."

"Yes," said Alberto. "This is the moment when everything could start. The head sits on the body very well now, and the body consequently has more volume."

"That's because the drawing is good," Diego said. "The space around the body is more solid now."

"It's only beginning," Alberto said, turning to me, "and you're leaving. That's a bore."

"Yes," I said, "and I feel quite remorseful about it, to tell you the truth."

"Don't feel that way," Alberto said.

However, I did. And later that evening I decided that, after all, I must stay longer if he wanted me to. In view of my affection for him and my admiration for his work, it seemed the least I could do. What were a few days or even a few weeks when considered in terms of what is timeless? I telephoned him and told him that I had decided to stay on. He thanked me but said that he had more or less made up his mind to send the painting to the Pittsburgh International Exhibition in the United States. Since he had won the prize for sculpture there in 1961, he was obliged, or expected, to send something, and he felt that it would be interesting to send the most recent work he'd produced. The latest possible date for delivering the painting happened to be that coming Friday, October 2. Therefore, Thursday was in any case the last day it would be possible to work on it. I said I'd certainly be glad to stay on for two extra days if he wished me to. He replied that we'd see about it the next day.

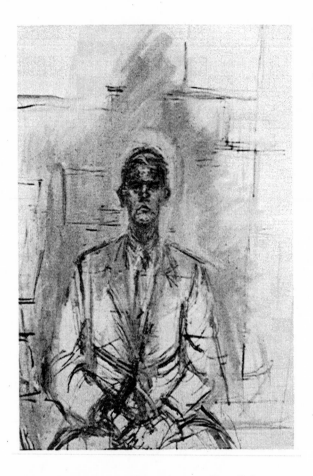

"Now I suppose you're going to demolish everything," I said as we began to work.

"Exactly!" he replied.

And that, of course, is what he began to do. He seemed at first to be in an excellent humor, laughing and joking about the constant state of flux of my features. But gradually, inevitably his mood became more somber as the work progressed. "It stinks, what I'm doing," he said. "Or maybe I shouldn't say that," he added, smiling at me.

"Maybe it isn't polite to you. I should simply say that it's very bad. But there's no question of my giving up painting now, not when things are going so badly, or sculpture, either. As long as there's the slightest chance, I've got to go on."

He told me that the woman poet who was still pursuing him had remarked that he must find it strange to paint the portrait of an American, because the American temperament is fundamentally so different from the European. Alberto had said that he didn't find it strange at all, and saw no difference. But she had insisted, observing that he portrayed the inner nature of the model as well as the outward appearance. "Not at all," Alberto had replied. "I have enough to do with the outside without bothering about the inside."

For some time he worked in silence, gasping occasionally and shaking his head, smoking cigarettes, painting over and over again the same part of the canvas, looking at me constantly as he did so. "I'm demolishing you with joy," he remarked after a while.

An hour and a half or more passed. Then he said, "We'll have to rest a little." He stood up and immediately began to work on the bust of Diego.

I looked at the painting. The head was in the midst of a transition and my disconnected features appeared to float vaguely in a gray cloud.

"The moment of truth has come," I said.

"Why?" he asked.

"We have to decide whether or not I'm leaving tomorrow."

"It's up to you."

"No. It's up to you. You're the painter, after all."

"But you're the one who's leaving," he said. "I don't want to influence you."

"I've told you," I said, "that if you want me to, | 95

I'll be happy to stay the two extra days."

"Well, if you put it that way," he said, "of course I want you to. Two more days could make all the difference."

So I telephoned to change my airplane reservation. Having done so, I felt delighted and relieved. Despite moments of fatigue, the experience had become for me a more and more vital one as time went on. To have put off the end of it made me, for my own reasons, certainly as happy as he could have been. I told him this when we started work again. He said, "I'm very glad, too."

He worked for a while, then said, "I'd give absolutely anything for someone else to paint you. I'd give everything I have and keep only enough so that I could end my days in an old people's home. I don't care about money, anyway."

"I've never known anyone so indifferent to material things," I said, "and to money in general."

"I spend a hell of a lot of it, though," he remarked.

"But not on yourself."

"Well, I'd be glad to give everything I've got for someone else to paint your head."

"You wouldn't have any trouble finding a taker for that offer," I said.

"To paint your head just the way I want it," he specified.

"In that case, there'd be no one."

"Right."

Annette came in and talked to us. The work had begun to go very badly. Or so he said. He moaned, stamped his foot, exclaimed, "It's abominable!" or "I'm so nervous I could explode!" or "I don't know how to do anything." Both Annette and I tried to persuade him to relax a little or to rest, but without success. However, finally he

said, "I don't even know how to hold the brush any more. We'll have to stop."

I stood up. He took the painting from the easel and stood it, as usual, under the light where we could study it from a distance. It was superb. It had never been nearly as good, I thought. The head stood exactly in the axis of the body, which, though still primarily a sketch, had acquired a new tension and solidity. The features were vivid and finely realized, and the likeness, I thought, was excellent, though idealized. So, after all, as I had suspected, it was indeed when the work might seem to him to be at its worst that to the objective observer it might seem best. I told him I thought the painting had never been better. He agreed.

Then I was suddenly overcome with regret at having changed the date of my departure, because I realized perfectly, after sixteen sittings, that without doubt he would paint over the head if he were to work on the picture again. And perhaps it would never afterward be as fine as it was at that moment. In fact, the chances seemed to me slight that it would, for he was not concerned with the painting as a single, objective work to be appreciated as such. That was my concern alone. He would naturally regard the picture almost as a by-product, so to speak, of his endless struggle to portray not merely an individual but reality.

"I'm leaving tomorrow," I said.

"The hell you are!"

"Well, if you ruin the picture now, I'll kill you," I said.

He laughed. "I'll certainly do it all over again from nothing. This is only the beginning. But to have made a start, that's not bad."

Annette and Diego also agreed that the painting had never before been better.

"Tomorrow we'll see," said Alberto.

Then he went into the bedroom to lie down, for he felt a pain in his chest. He had said, when I told him that I would stay the two extra days, that we must celebrate, so I followed him into his room and fixed myself a Scotch and water. We talked for some time. Suddenly Alberto sat up in the bed and began to sing very loudly, "I am cured!" Annette hugged and kissed him. He said he wanted to go to the café to eat something. We all three went over there. I sat with them for a time.

"Tomorrow," I said, "you'll be walking a tightrope." But I felt that it was I in a way who would actually be on the tightrope, because, having once seen how beautiful the painting could be, I felt desperately anxious that it should not ultimately remain less so. And yet I was powerless to affect its final state. Or was I? I began to wonder.

"Oh, tightropes," he said, shrugging. "I've got plenty of those."

As I left he called after me, "Thank you, thank you for everything."

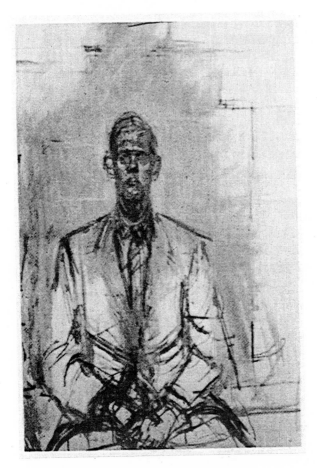

"I suppose there's no use in my saying a thing," I said when we started work together the following afternoon.

"About what?" he asked, then added at once, "Oh, about leaving the picture as it is. That's out!"

"All right," I said, "go ahead and demolish it."

He began to paint. At the beginning he seemed very optimistic. He said, "It's really rolling along today." And a little later, "Now I'm doing some-

thing that I've never done before. I have a very large opening in front of me. It's the first time in my life that I've ever had such an opening."

Anyone who knows Giacometti at all well has certainly heard him say that he has just then for the first time in his life come to feel that he is on the verge of actually achieving something. And no doubt that is his sincere conviction at the moment. But to a detached observer it may seem that the particular piece of work that provokes this reaction is not radically different from those which have preceded it. Moreover, it will in all likelihood not seem radically different from those that follow, some of which will certainly provoke the same reaction. In short, the reaction is far more an expression of his total creative attitude than of his momentary relation to any single work in progress. He might deny this, but I believe that it is true. Probably, as a matter of fact, it would be vital for him to deny it, because in the earnest sincerity of the specific reaction dwells the decisive strength of all the others, past and to come. If Giacometti cannot feel that something exists truly for the first time, then it will not really exist for him at all. From this almost childlike and obsessive response to the nature and the appearance of reality springs true originality of vision.

"It's possible for me now to undo the whole thing very quickly," he said. "That's good."

"Why?" I asked.

"Because I'm beginning to know what it's all about."

"What?"

"A head," he replied simply.

Before long, of course, the work began to go less well. He moaned, gasped, and at last uttered a loud scream of exasperation.

"I'm not afraid," I said.

"Of what?" he asked.

"Of you. Because you're roaring like a wild animal."

"Yes!" he cried. "And I'm a wild animal that's sure of its prey!"

Some time passed. Suddenly there was a knock at the door. He opened it and outside stood a small man who quickly explained that he was a representative of the Indonesian Embassy in Paris, that Giacometti's work was well known and admired in Indonesia and that the Foreign Minister of that country, who was coming to Paris three weeks later, requested the privilege of being permitted to come and call on Giacometti in his studio. He replied that he would be happy to receive the diplomat. When he returned to his stool and started to work again, he said, "Diego was outside, too. He was very impressed that the Minister wanted to come and see me."

"And you?" I inquired.

"Oh, I'm impressed, too," he admitted, smiling broadly.

Presently he announced, "I'm making everything disappear again."

"That's no surprise," I said, and perhaps I involuntarily, unconsciously, added a sigh.

"Are you angry?" he asked.

"Of course not!" I exclaimed. "Why should I be?"

"Because I'm ruining everything."

"Don't be ridiculous."

"But I wouldn't want to lose your friendship."

"Now you're really talking nonsense," I said.

He shrugged. "Well, at least I have the courage not to be prudent. I dare to give that one final brush stroke which abolishes everything."

"But why do you have to do it?"

"Because there's no other way out."

"I know. It was a stupid question, wasn't it?"

He didn't reply. He worked on for a time. Then he said, "It's a good thing for me to have a deadline I'm working against like this. It adds tension. But we'll have to rest for a little while now. The paint isn't going onto the canvas at all well. The soup's too thick, too much turpentine. I shouldn't let so much paint accumulate on the canvas this way. It makes the work harder. From now on I'll scrape it off with a palette knife. But for your picture it's too late to do that. The surface is so shiny I can't see a thing. We can go to the café for half an hour. The paint isn't going on at all. It's the revenge of the brush on the painter who doesn't know how to use it."

"Well," I said, standing up, "the brush still needs the painter all the same."

"The painter needs the brush even more," he remarked.

The painting was very gray, uncertain, dislocated, a grave disappointment compared to its appearance an hour and a half before. But I knew that that was only temporary, in any case, and that once again from the constant flux of layer upon layer of paint it could emerge admirable and stark. But would it?

On the way to the café he said, "There's an opening. That's sure. This is the first time in my life I've had such an opening. It's the very first time. You see, you've done me a tremendous favor. I've never had an opening like this before."

In the café we talked little, read the papers, and drank coffee. Half an hour later we were back at work in the studio. And at once things seemed to go very badly. He began to gasp and murmur insults to himself: "You don't know how to do anything. You're a damn fool! It's abominable!" etc. I said nothing. When the work was so obvi-

ously difficult and painful, it seemed that to sit still and keep quiet was the least I could do, and the most. Despite the very apparent anguish of it, he kept working till the light began to go. Then he said we'd have to stop.

We inspected the results of the day's work. I had inferred from his constant groaning that the picture might look quite good. And I was right. Though certainly not as clear and intense as it had been the day before, still it was no longer the amorphous thing we had left when we went to the café.

"It's come back since an hour ago," I said.

"It's beginning," he admitted. "There's an opening. It's not bad. Something can be done. But it wobbles. It's uneven."

"We'll set it right tomorrow," I said.

"Oh, tomorrow, tomorrow," he murmured. "Who knows?"

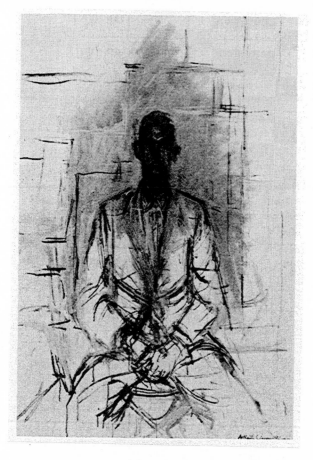

October 1 was the eighteenth day on which I
posed, and it was the last. And this time I really
believed that it would be the last. I felt elated and
alarmed. If the work went badly that afternoon,
there would be no changing it afterward. The pic-
ture would remain forever as it was. I couldn't
help feeling afraid that my permanent image, so
to speak, might turn out to be a gray and incon-
clusive shape. But I had thought of a way in
which I might, perhaps, influence its final state.

Before he began to work that day he stared at the painting and said, "It's terrifying. The whole thing is lopsided again."

However, with a sigh he started to work, grimacing as he did so, constantly looking from the canvas to me and then back at the canvas again.

"I don't mind telling you that I'm demolishing everything," he soon declared.

"Of course," I said.

After working for a time, and when everything was apparently at its worst, he suddenly uttered a loud cry, let his arms fall, and said, "I'm giving up painting for good. It's horrible. I'm right back where I was in '25."

I said nothing. A minute, two minutes passed, then he began to paint again. He said, "When I was forced to give up working from nature in 1925, I began to make objects—like the *Palace* in New York—which had primarily an emotional reality. But they were just stopgaps. All during the surrealist period I was haunted by the realization that sooner or later I would have to go back to nature. And that was terrifying, because I knew at the same time that it was impossible."

The work continued and seemed to go no better, which I, however, took as a promising sign. "One might imagine," he said, "that in order to make a painting it's simply a question of placing one detail next to another. But that's not it. That's not it at all. It's a question of creating a complete entity all at once."

"Is that," I asked, "why Cézanne said that it was impossible to add a single brush stroke to a painting without changing the whole thing?"

"Exactly."

As so often, he presently said, "Let's have a look at you, young man."

"I'm not really a young man," I said, "but I'm a man who's still young."

He shrugged. "Youth," he said, "doesn't necessarily mean much. I'm very young, whereas all my contemporaries in Stampa are old men, because they've accepted old age. Their lives are already in the past. But mine is still in the future. It's only now that I can envisage the possibility of trying to start on my life's work. But if one could ever really begin, if one could have *made* a start, then it would be unnecessary to go any further, because the end is implicit in the realization of the beginning."

And after a little while he said, "It's not a bad thing at all, this pressure of having to deliver the painting tomorrow for the Carnegie exhibition. It makes me much more audacious. I'm willing to risk everything. And I'm glad to send the very last thing I've worked on. So people can see precisely the point I've reached. There'll be no cheating. If the picture is no good, that's just too bad. At least I'm being honest. And for a sculpture I'm going to send a plaster cast of that bust of Diego that I've been working on from memory. I worked on it last night, and Diego made the cast this morning."

A few minutes later Diego brought the fresh white cast of the bust into the studio and set it down on the table behind Alberto, who turned to look at it, murmuring, "What an odd thing!" And he suggested to Diego that it would look better if the base were rectangular rather than uneven and roughly oval, as it was. Diego took the bust away again. Alberto began to paint once more, but after a few minutes he turned round to where the bust had been, as though to reexamine it, and exclaimed, "Oh, it's gone! I thought it was still there, but it's gone!" Although I reminded him

that Diego had taken it away, he said, "Yes, but I thought it was there. I looked, and suddenly I saw emptiness. I *saw* the emptiness. It's the first time in my life that that's happened to me."

Later he said, "You look like an Egyptian sculpture, but more handsome."

"Why more handsome?" I asked. "Because I'm alive?"

"No. Simply because you're not an Egyptian sculpture, that's all."

Then he said, "You're leaning to the left." When I moved slightly to the right, he exclaimed, "No, no! It was all right. Wasn't it all right? I think it was all right. But look at me. Here!" And I stared him in the eye.

We had been working for about an hour and a half when he said, "Now we'll have to stop for a while."

I stood up. The painting, I thought, was not at its best. The head seemed somewhat askew and the lower part of the face was vague. But neither of us said anything about it then. We went out into the passageway to Diego's studio to see how the new base for the bust was coming along. It looked much better than it had. We talked with Diego a few minutes, then went back to Alberto's studio. He took the painting off the easel and studied it.

"Maybe I'll leave it as it is," he said.

That prospect didn't appeal to me at all. Not only for my own sake but also, and far more, for his, I felt it was desirable that the painting should ultimately remain as near its best as possible. And I had finally thought of a way in which, perhaps, I might actively contribute to that end.

I said, "It seems to me that in the time left we could go still further."

"There's an opening," he said. "That's sure."

I took the canvas and put it back on the easel. "Shall we try?" I suggested.

He sat down on his stool, took the palette and brushes, and studied the painting. I sat on my chair and assumed the pose in which at times it had seemed that I might be paralyzed forever. He looked at me. "Ah la la," he murmured, "it's really terrifying." But he began to paint.

From the very first the work obviously went badly. I took that as a promising sign. However, inasmuch as this was unquestionably the last sitting, I felt that I could not and, if possible, should not leave the outcome entirely to chance. He would certainly be inclined by nature to pursue the cycle of flux till the daylight was gone, and even a few minutes thereafter, then leave the painting as it happened to be. If it happened to be in a state of gray and vague decomposition, he would accept it, because the painting was by definition an inadequate semblance of what he visualized as an ultimately tolerable representation of reality. I, on the other hand, being motivated in my attitude toward art in general and toward this painting in particular by other criteria and other objectives, felt considerably less fatalistic. I had made up my mind that I would do what I could to stop his work when the positive element, so to speak, of the creative impulse was at its peak and just before the negative element began to act. Since I could not see the picture, however, I would have to guess when that crucial moment had come. So I observed with scrupulous care which brushes and colors he was using.

He groaned, he sighed, he made all the self-deprecating and exasperated remarks to which I had become so accustomed. At length he said, "Are you angry?"

"No," I said, "of course not. How could I be?"

"Because I'm ruining everything."

"Don't be absurd."

"But it's true."

"That's only your opinion," I said. "The artist isn't supposed to be able to judge his own work. Anyway, you can't possibly see it in the same way I do, and it may be beautiful to me but ruined to you at the same time."

"We'll see," he said.

He had begun to work with one of the fine brushes, using grayish and white paint, working on the head only. Then after a time he began to use the large brush with white, painting the area around the head and shoulders and finally part of the face, too. This led me to infer that little by little he was painting out what he had previously done, undoing it, as he said. Presently he took one of the fine brushes again and began to paint with black, concentrating on the head. He was constructing it all over again from nothing, and for the hundredth time at least. I knew that when he had reworked the entire head he would "finish" it by adding highlights and defining the contours with white. At that point he would normally have begun to use the other of the fine brushes with the mixture of grayish and white pigments, which would indicate that he was yet again starting to undo what he had done. It was exactly at this point that I meant to try to stop him.

Although he believed in the active participation of the model in his work, I'm not sure that he would have liked the idea of anything quite so arbitrary and calculated as my plan. Consequently I took care that he should not notice how closely I was watching every move he made. But I observed him with painstaking attention, and when the moment I had foreseen came, I said, "I'm

very tired. Do you mind if I have a little rest?" It was the first time in all the sittings that I had made such a request, and I didn't think he would refuse.

"Wait a minute," he said. He painted a few more strokes, using only white pigment, then said: "All right. You can stand up. I just had to do the eyes."

I stood up, went behind him, and looked at the painting. It was superb. The awkward vagueness of forty-five minutes before had completely disappeared. Never before had the picture looked just as it did then, and it had never looked better. I said, "It looks fine. Why not leave it as it is now?"

He sighed. "It's too bad," he said. "We could have gone so much farther. There's an opening. There's a real opening. It's the first time in my life that I've had an opening like this."

He took the painting from the easel and stood it at the back of the studio, then went out into the passageway to look at it from a distance. "Well," he said, "we've gone far. We could have gone further still, but we have gone far. It's only the beginning of what it could be. But that's something, anyway."

"I think it's admirable," I said.

"That's another matter," he replied.

Diego brought in the bust with its new base, which Alberto liked but found a little too wide. He took a knife and hacked away the damp plaster at either side till he was satisfied. The bust was one of the more exaggerated and distorted of the innumerable versions of Diego's head that Alberto has done. To compare with it, he brought out two other busts which he had recently sculpted from life.

"Which do you prefer?" he asked me. | 110

"The last," I replied without hesitation, "the one from memory."

"Why?" he asked.

"Because it makes the other two, though they were done from life, look dead."

"Exactly. It's strange, isn't it? It's because in the busts from life everything is false."

"But why should that be?"

"Because the element of illusion in the busts from life is not great enough. It's the same thing that makes a Cycladic head so much more alive and convincing than a Roman portrait bust. To make a head really lifelike is impossible, and the more you struggle to make it lifelike the less like life it becomes. But since a work of art is an illusion anyway, if you heighten the illusory quality, then you come closer to the effect of life."

"But how do you do that?" I asked.

"That's the whole drama," he answered.

We went to the café. In the street he said, "There has been, after all, a slight progress. There's a very small opening. In two or three weeks I'll have an idea if there's any hope, any chance of going on. Two or three weeks, maybe less. I have the portrait of Caroline to do, then there's the one of Annette. And I want to do some drawings, too. I never have time for drawings any more. Drawing is the basis for everything, though. I'd like to do some still lifes. But we did make a little progress, didn't we?"

"Yes," I said. "We went quite far."

In the café, however, he quickly seemed to forget that there had been any progress at all. He gasped and pounded his fist on the table, which caused the people sitting nearby to stare, a fact of which he remained unaware. He shook his head and exclaimed, "Nothing is the way I want it to be, nothing at all."

"But there has been progress," I insisted.

"No, no," he said. "Maybe in two or three weeks. I'll work for two or three weeks more and then if there's no opening at all perhaps I'll have to give up for good."

He made several drawings on the cover of a magazine he'd brought with him and ate the usual hard-boiled eggs and ham, with two glasses of Beaujolais and two large cups of coffee. Then we returned to the studio. He said that he wanted to come with me the next day to the airport, so we made arrangements to meet. It was strange, and sad, to realize that this was the last day.

The following afternoon at about two-thirty I went to the studio in a taxi. Alberto was there, but the painting had already been taken away, still wet, to be packed for shipment, along with the bust.

"It's gone," he said.

"I'm gone," I said, "and I'm leaving. It seems very strange, doesn't it?"

"It's too bad. We'd only started. We could have gone on for a long time."

"I know," I said. "It's very strange to be here in this place where I've really lived more than anywhere else in the past weeks and to know that it's for the last time."

"You won't be gone so long," he said. "And when you come back we'll begin again. We'll go further."

"Yes," I said.

We went out and got into the taxi. It was a gray, cold day.

At the airport, when my baggage had been checked in, he suggested that we go to the bar and have a coffee. He had not seen the new terminal building and was very interested in it. He enjoyed

observing the travelers of different nationalities. But he could not forget for very long, if at all, the urgent things he had to do. During the next ten days, he said, he would work on another bust of Diego from memory and on the portrait of Caroline. And perhaps, he added, he would have time to do a few drawings. He wanted to do some drawings.

"At the end of the month," he said, "I'll go to Stampa. And there I can do some drawings. I can do still lifes and some figures. The woman who keeps house for me there will pose. She has posed before. I want to do some drawings."

As he spoke he gazed across the crowded waiting room of the airport terminal. On the surface of the table his index finger, as though it were a pencil, moved back and forth across the shiny Formica with the insistent gesture of drawing. His eyes no longer appeared to focus upon any particular object, but rather to see beyond the present place and time. Through his finger as it moved, his entire being seemed to flow from him into the ideal void where reality, untouched and unknown, is always waiting to be discovered.

Then it was time for us to say goodbye. I tried yet again to thank him for everything. But he refused to listen. We went together to the top of the stairway and there shook hands twice.

"You'll come back next year," he said.

"Yes."

"We made progress together. We'll do it again, won't we?"

"Yes, I hope so."

"You'll come back and we'll start all over again. And you'll write often."

We looked each other in the eyes—as we had so often done during the past weeks—but differently. Then he turned and started down the stair-

way. I went in the other direction, toward the departure gates. But we both looked back and waved, twice.

I wrote to him. When he answered, he said, "I've been in Stampa for a week now, and I'm working a lot. I'm sleeping a lot, too. I continue with the same things. Always those heads! I certainly hope I can do yours again someday. I enjoyed very much all the time when you were posing for me."

So did I.

Though I have known Giacometti for a long time and have written several articles about him, it had never occurred to me before to make detailed notes describing our meetings. And it would never have occurred to me this time either except for the fact that all summer I had been writing long detailed letters to a friend in New York about what I was doing. And because Giacometti is of great interest to both of us, I had related my meetings with him in particular detail. From Stampa I had in August written a letter of forty pages, and from Paris, three equally as long before I began to pose. When the sittings began, however, it was obvious that letters couldn't keep pace with the rhythm of what was happening and that I would be reduced to the expedient of notes. I mention this only in order to emphasize that even before the day of the first sitting I had formed the habit of paying scrupulous attention to what Giacometti said, in order to remember it and write it down later. And from the beginning I felt that notes relating to the particular circumstances surrounding the creation of a particular work of art might later be used to write just such a text as this one.

Most of these notes were written in the evenings immediately following the afternoons during which I had posed. But many of them were made on the spot in a pocket notebook whenever I had an opportunity to write without being observed by Giacometti himself. He found me at it only once, when he returned sooner than I had expected from talking on the telephone. When he saw me writing, he asked, "What are you doing?"

"Just making a note," I replied, and that seemed to satisfy him.

The somewhat surreptitious character of my note-taking was not motivated by a fear that he would disapprove of what I was doing. In fact, I

think he will be very curious, and perhaps surprised, to learn what the experience of posing for him can be like. But I felt that it might inhibit the spontaneity of his work and of our talk if he knew that I intended to describe it all in writing. Moreover, I did not want him to be able to feel in any way that I thought of him as a specimen under observation. I didn't. And yet somehow I did. To me Alberto is, of course, first of all a friend for whom I feel great affection and esteem. But he is also a great artist. It is sometimes difficult to take account of both men at the same time. However, they both exist simultaneously and I have tried here as much as possible to do justice to both.

Needless to say, there are many remarks and references which for the sake of discretion I have had to delete. If the account seems at times uneven, it is in part for this reason.

After the first sitting, when I realized that the portrait was to exist in more than one state, it occurred to me that a photographic record of its metamorphoses might, in addition to my notes, prove interesting. So I left my old camera at the studio and every afternoon before the work began I would take the painting out into the passageway and photograph it. Giacometti considered this activity with apparent indifference. But one day he said, "It's not worthwhile to photograph that picture every day."

"Now that I've started," I replied, "I'm going to keep it up."

He did not protest further. But, unfortunately, I am at best a poor amateur photographer and most of the photographs did not turn out very well.

As for the written portrait, it's a paltry thing compared to the real person. But Giacometti is, after all, the first to understand that a portrait can

achieve only a semblance of reality. Therefore, I hope that he will consider this one with indulgence. And I hope that others may see in it a small part of what makes him such a remarkable man and such a supreme artist. To see even so little will be to see very much.